art BEFORE BREAKfast

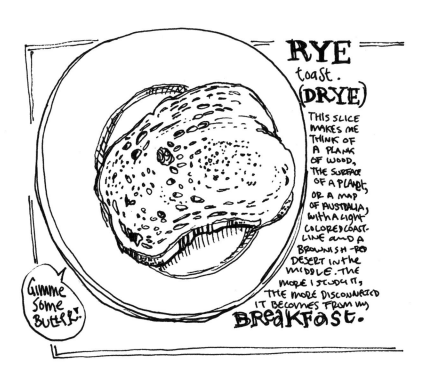

RYE toast.
(DRYE)

THIS SLICE MAKES ME THINK OF A PLANK OF WOOD, THE SURFACE OF A PLANET, OR A MAP OF AUSTRALIA, WITH A LIGHT-COLORED COAST-LINE AND A BROWNISH-RED DESERT IN THE MIDDLE. THE MORE I STUDY IT, THE MORE DISCONNECTED IT BECOMES FROM MY BREAKFAST.

Gimme Some Butter!

aRt BEfoRE BREAkfast

A Zillion Ways to Be More Creative,
No Matter How Busy You Are

by Danny Gregory

CHRONICLE BOOKS

San Francisco

More books by Danny:

An Illustrated Journey

A Kiss Before You Go

An Illustrated Life

The Creative License

Everyday Matters

Copyright © 2015 by Danny Gregory.

Library of Congress Cataloging-in-Publication Data available.

ISBN: 978-1-4521-3547-2

Manufactured in China.

MIX
Paper from responsible sources
FSC® C008047
www.fsc.org

10 9 8 7 6 5 4 3 2

IMAX is a registered trademark of IMAX Corporation; Jack Daniel is a registered trademark of Jack Daniel's Properties, Inc.; CliffNotes is a registered trademark of IDG Books Worldwide, Inc.; Post-it is a registered trademark of 3M Company; Play-Doh is a registered trademark of Hasbro, Inc.; Windex is a registered trademark of S.C. Johnson & Son, Inc.; Sharpie is a registered trademark of Sanford L.P. Newell Operating Co.

Chronicle Books LLC
680 Second Street
San Francisco, CA 94107
www.chroniclebooks.com

FOR Jenny—
who always has
time for me.

This book is for people who don't have time to read it.

You don't have a second to catch your breath.

To smell the roses or the coffee.

Your life is getting more and more full and crazy.

Which is why you need to add one more thing to your to-do list:

[√] Make art.

Seriously, *art*? Yup.

The Big Problem: Time

I know you don't have much time, so let's get right to the point.

You are about to discover that

(a) making art will make you saner and happier,

(b) you don't need to think you have "talent" to make beautiful art,

and

(c) art making can fit into the craziest, busiest, most hectic and out-of-control lives — even yours.

And it'll take just a few fun minutes a day.

Got it? Moving on...

9

art will make your
life richer.
and more fun.
and better.
and cooler.
and less stressed.
and . . .

Be here. Now. Art stops time. When you draw or paint what's around you, you see it for what it is. Instead of living in a virtual world, as we do most of the time these days, you will be present in the real one. Instead of focusing on all the things whirring in your head, you will be able to stop, clear your mind, take a deep breath, and just be. You don't need a mantra or a guru. Or an app. Just a pen.

Tell your story. Life is just a long succession of small epiphanies. You need to stop and seize them. By making art, you will be recording what you are living through and what you are learning about it. A drawing and a sentence or two in a sketchbook turns those everyday moments into something significant. Your art will set a frame around it and give you perspective on what really matters. Over time you will build up a book of memories—a true record of what's important in your life.

Welcome to the world. It's not perfect, but it's beautiful. And the most beautiful things have character and experience built into them. There's a lot to learn and appreciate in a chipped mug, a half-eaten apple, the tiny lines in the leather of your dashboard. Making art will show you how much you already have. Your real treasures. A brand-new Maserati is a lot less beautiful to draw than a rusty old pickup.

WALNUTS

OF THE YEAR. SOME SMALL. All mysterious.

Sudoku no more. You will never be bored or waste time again. Every day is full of those moments between activities. Waiting in the doctor's office, watching mindless TV. Instead of reading tweets on your phone, you'll make a piece of art. Every minute of your day counts. Make it worthwhile.

Why it matters

We all live in chaos. It's the natural state of things. Physicists call it entropy—everything is always changing and unraveling and ultimately turning into cosmic mush. That's why your desk gets cluttered and your calendar gets filled. It's physics.

Creativity is the act of shaping the mush of the world around us into something—of creating your own order. I'm not talking about going crazy and compulsive with a label maker and color-coded files. I'm talking about having a vision of what you want things to be like and moving toward it.

I assume that, deep down, you want to have more creativity in your life—that's why you have this book in your hands. But you just don't know how to fit it into the chaos of your day. There are always

too many things to do, too many obligations and chores that take precedence over *you*. Maybe you think to yourself, "Sure, I'd love to make art, but I don't have the time to indulge myself right now. Maybe on the weekend, on vacation, when I retire, etc."

But creativity isn't a *luxury*. It's the essence of life. It's what distinguishes us from the mush. And it's why our ancestors survived while other less adaptive critters perished. They responded to change by being creative in some way, by inventing a new answer to the chaos.

And that's what you need to do to make the most of your life, every day of it. To be inventive, open, flexible, in touch. To have perspective on what matters to you. To deal with change without being overwhelmed. And that's what creativity offers you.

Creativity can become a habit that fits into your life, like Pilates or flossing, only a lot more fulfilling. You just need to shift your perspective on what it is to be creative. It doesn't mean you have to be a full-time artist. It doesn't mean you need lots of training or supplies. Or time. It doesn't mean you need to be a so-called expert.

You just have to be *you*—and express what that means.

13

art with a small "a"

Art with a big "A" is for museums, galleries, critics, and collectors.

art with a small "a" is for the rest of us.

Art is a business, an industry, a racket.

**art is about passion, love, life, humanity—
everything that is truly valuable.**

Art is sold, resold, put under the gavel, and insured up the wazoo.

**art with a small "a" is not a product.
It's a point of view. It's a way of life.**

Art is made by trained professionals and experts.

**art is made by accountants, farmers, and stay-at-home moms at
restaurant tables, in parking lots, and laundry rooms.**

Art takes Art School and Talent and years of Suffering and Sacrifice.

art just takes desire and 15 minutes a day.

You may not be an Artist. Big whoop.

**But I know you can make art—
with a wonderful, expressive, teeny, tiny a.**

aHa! the aRt EFFect

It's ironic that people speak of artists as dreamers. I think they are the most grounded people around. Conscious and present. As an artist, you really see life, connect with its beauty, and create something that shares those observations with others. You notice things.

That sort of consciousness needs to be worked at. You need to make a habit of seeing, connecting with, and commenting on the everyday. And you need to do it every day, if even for a handful of minutes.

One MiNute aBout Me

art Before Breakfast is based on hard-won experience. I've lived this creative dilemma every day of my adult life. No time to make the bed, let alone art, but a burning need inside to express myself.

Then I discovered art—with a small "a"—and it set me free. It gave me perspective and purpose.

Even as a parent and a full-time executive in the busiest city on earth, I found time to fill fifty sketchbooks with drawings and watercolors and to write and contribute to more than twenty books. And I did it one small, hurried bite at a time, writing and drawing in the spare time I managed to uncover between responsibilities and sitcoms.

I hate to put it this way but—well, if I can do it, you can, too.

But enough about me…Let's talk about how you're going to do this.

17

How to Develop a creative Habit

Executive summary: **Making art doesn't require a lot of gear and time and expense. It can fit into the life you lead today. It can become a habit. You just need to make a couple of small agreements with yourself.**

1. Do something creative every day. Anything. I will give you loads of suggestions of things you can make, all of which will take 15 minutes or less. And they don't have to be 15 continuous minutes. A couple of quick drawings done while you're waiting for the kettle to boil will help get you there.

2. Commit to doing this for, let's say, 30 days. That's the hardest part, that initial period that reconditions your brain to get used to this new habit.

3. Don't go crazy with art supplies at first. Just get a sketchbook and a pen that'll fit in your bag and keep them with you for when a moment opens up. Later we'll branch out and try some other materials and techniques.

4. Be consistent. Look for opportunities, cracks in your schedule. Don't go to bed if you haven't done something creative yet that day. Draw your alarm clock or Jimmy Fallon.

5. Skip perfection. A lame drawing is better than no drawing.

6. Just try it. Wait till the 30 days are up to judge whether it was worth doing (although, I know it will be).

7. Get a drawing buddy. Or join an online group like Everyday Matters on Facebook. Encourage and push each other.

8. Read this book when you are stuck. But don't read it instead of drawing. My feelings won't be hurt.

9. Get used to eating cold toast. Draw your breakfast every day. Then eat it.

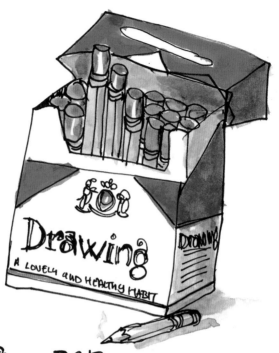

smoking and art

Did you ever smoke cigarettes? Ugh. But now think of taking up drawing as a similar habit.

Instead of lighting up after a meal, draw your dirty dishes.

Instead of smoking in a meeting (yes, we all used to, back in the day), draw your colleagues around the table.

Don't have a smoke as soon as you wake up in the morning. Draw the folds in your bedsheets, the profile of your sleeping spouse, the view through the blinds instead.

Draw on a plane. The "no drawing" light is always extinguished.

A pack of cigarettes costs the same as an empty sketchbook. A lighter costs the same as a pen. Carry your book and pen with you everywhere. It's a lovely, healthy habit.

Shop, but not till you drop

First, get yourself a **sketchbook**. You can probably find one in the art supply store, drugstore, or online. Buy one with decent paper that ink won't bleed through. Make it a convenient size so you can keep it with you all the time, in your bag, by your bedside. But not so small that you feel cramped.

Also, get a **pen** that feels nice in your hand and makes decent lines. Start using them.

LET'S GET STARTED

A week of 15-minute drawing lessons

M T W Th F

This is going to be easy. I swear.

Drawing is about observation, about dismantling what you are looking at into the lines that make it up, and then recording those lines, one after the other, on a piece of paper.

That's how a computer program works, zillions of tiny steps performed in the right order at the speed of light. A Beethoven symphony? Just read every note from the overture to the finale. French cooking? All you need is a clear step-by-step recipe and a good bottle of wine. The only thing that's truly impossible is building one of those IKEA bookshelves.

Drawing works the same way.

Most anything you'd want to draw is made up of straight lines and curves and organic squiggles. You can almost certainly draw a short, reasonably straight line. And with a little care you can probably draw an arc or a fairly round circle. To improve your accuracy, just slow down. And practice will make you better. And as for the squiggles, well, come on, they're squiggles.

But you don't want to just learn to draw lines and arcs, any more than you want a lesson on how to boil water or how to play a single note on the piano. It's putting all those parts together that makes the idea of drawing satisfying and challenging. But that's all it is—a challenge, not an impossibility, no matter who you are.

The key to what we'll be doing this week is to flip a switch in your head that helps you see differently. It's not about driving yourself crazy with super-accurate measurements or perfection. We're not doing an engineering drawing here, we're learning about ourselves.

Be kind to yourself, free your mind, and get set to have more fun on a Monday morning than you thought possible.

Monday's Lesson

Make yourself a nice balanced breakfast. *Visually* balanced, that is: a plate with some toast on it, a butter dish, a jam jar, a cup of coffee, a milk pitcher, a glass of juice, some cutlery.

Oh, and a sketchbook and a pen, too.

Now, start drawing the outside edges of the objects on the table. Make one slow continuous line that traces around the plate, up the side of the mug, along the knife, and so on. Really slow and careful, no erasing or hesitation. Just draw their outer edges until you have made one big shape.

This is called a contour drawing.

It shouldn't take you more than a couple of minutes to draw the whole contour, but try to go as slowly as you can bear. Really look at each object.

Ask yourself questions as you go. From where you're sitting, the plate is not a circle, it's an oval, flattened, right? And the mug, how does it look where it meets the table? How far is it from the butter dish to the knife? Don't answer these questions with words, only with lines on the page.

Now, spend another few minutes drawing the shapes inside the shapes. Draw the opening in the top of the mug. Draw the lines where the handle meets the body of the mug. Place the toast on the plate. Is it a square? Or does it slant away? How far is the piece of toast from each edge of the plate? You don't have to draw every single line, just enough to show what you are seeing.

Tuesday's lesson

Another day, another breakfast. On a fresh page in your sketchbook, draw the visible surface of the table under your breakfast.

Draw the shape of the bit between the plate and the mug, the napkin and the jam jar. All you are drawing is table, a bunch of weird shapes of the spaces between things.

High five! You just drew "negative space." It's a concept that'll come in very handy, very soon.

Aha! Your eyes don't deceive you. Your brain does.

Try very hard to draw what you actually see. Not what you *think* you see, but what is actually passing through your eyeballs.

F'r instance, a plate may look like a circle from a certain angle, but from where you are sitting, it's probably a stretched-out oval. You may think of toast as a square thing, but it may actually be a lopsided rectangle. The bottom of a glass seems as though it should be flat, but it's probably quite round as it curves toward you. So, look before you draw and believe what your eyes, not the rest of your head, tell you.

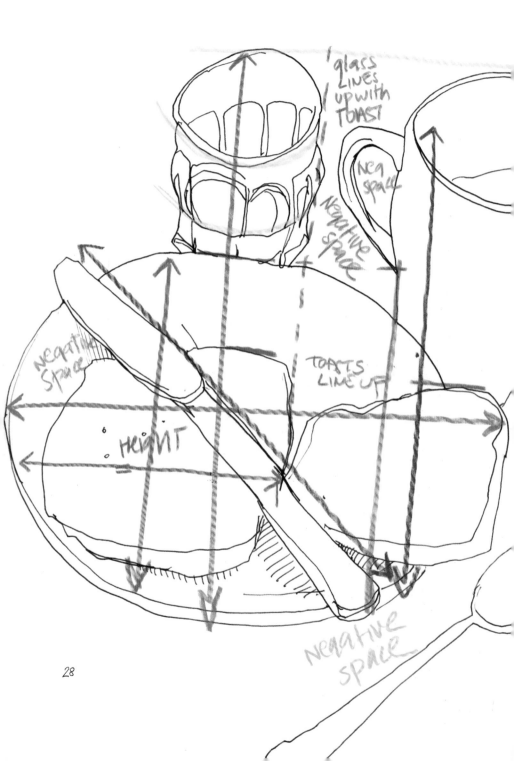

glass
LINES
up with
Toast

Neg
spac

Negative
space

Negative
Space

TOASTS
LINE UP

HEIGHT

Negative
space

28

Wednesday's Lesson

Today we'll do one more contour drawing of your breakfast table, the outline. But this time, we're going to draw the interior shapes too. And to make that easier, we're going to take some measurements and pay closer attention to the apparent distances between things.

Lock your elbow, hold up your pen in the air, at arm's length, and use it as a ruler. Close one eye. (Yes, you look like a real artist now.)

From where you are sitting, measure the width of all the dishes together in a group and compare it to the height. Let's say it was one pen high by two and a half pens wide. Transfer those measurements to your page. Now when you draw the contour, your proportions will be more correct. Use the pen/ruler to measure the width of your toast and compare it with the height of, say, your plate.

Pay attention also to how things line up. Where is the top of an object on one side of your breakfast compared to one on the far side? Is the object in the lower left-hand corner really in line with the one on the right? Or is it a bit lower? Keep checking yourself. If you need to correct and draw a new line on top of an old one, don't worry. Also, remember yesterday's observations of negative space to position things properly on the page and relative to each other.

Wahoo! *Contour, negative space, and measurements.* You just learned the three important lessons in drawing and saved yourself four years of art school.

Now, try the following quick-and-easy extra-credit exercises to round out the week.

Thursday's lesson

Open your medicine cabinet. Draw the shapes of the objects on the top shelf. Don't think about what the objects are. Just draw their outer edges until you have made one big shape. Try to go slowly, but it shouldn't take you more than a couple of minutes. Ignore your brain. Listen only to your eyes.

Now draw the next shelf. Then the next one. Brush your teeth.

Friday's Lesson

Finish drawing your cabinet. Draw the inside lines of the objects on the top shelf. Don't copy every word on each label, just draw enough so it's recognizable. Keep moving. TGIF.

Aha! Ommmm.

When you sit down to draw something, time stops its crazy dance. You will feel your mind focus and quiet. A 10-minute drawing can leave you feeling composed and refreshed. It's not about the lines on the page, it's about the way your eyes, brain, and hand come into alignment, about how you are mooring yourself to the here and now. At first, your monkey mind will chatter and distract you, but soon you will find you can snap right into this state of calm and focus. I have never been able to empty my mind through traditional meditation, but a simple drawing before breakfast starts my day off in a connected, grounded way.

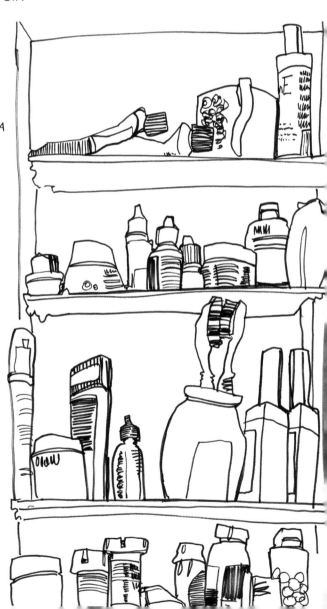

Saturday's Lesson

Go to the kitchen. Start the coffee machine. Look out the window. Draw the shape of the sky, its edges against the buildings and trees. One single continuous line that goes around antennas, telephone wires, rooflines, and chimneys. No clouds, no planes, just the outside shape. Now, have a croissant and caffeinate.

80/20 Rule

Keep your eyes on the things you are drawing 80 percent of the time and on your page just 20 percent.

If your drawing is wonky, cool. That's expressive. That's art. Move on.

Sunday's lessʒn

Stay in bed. Look out the door at the hallway or whatever is beyond. Hold up your pen at arm's length. Lock your elbow. Close one eye. Use your pen like a ruler to measure the width of the door. Now, rotate your pen 90 degrees and measure the door's height. Draw that door on your page, using these measurements—say, one pen wide and three pens tall.

Now measure the location of the door handle: Let's say it's about one pen length from the bottom of the door. Now note the other things you can see down the hall and measure them, relative to the handle and the landmarks you've observed on the doorframe. Transfer each measurement to your drawing. Draw all the shapes within the doorway until you've completed the scene.

Awesome! Now you can draw absolutely *anything*! Get up and go have brunch.

aHa! WResTLing with your BRain, who is that in there?

As you start to draw, you may start to hear voices. Don't worry, that's normal.

It might be your mother, your third-grade art teacher, your boss, or the devil himself.

The voice is reminding you of *all* the reasons that you are wrong to pursue your creativity: art is a waste of time, you'll never be able to draw, the author is an idiot, you have laundry that needs folding, blah, blah.

Here's how to respond to the hecklers. Don't give in. Don't argue. Smile politely and just say, "That's great, we'll talk about it later. Right now, I'm drawing."

It's that simple. Push the voices back into the darkness of your head and just give yourself 10 minutes to draw something. Hum, whistle, and keep drawing.

These voices-the inner critic, the inner nag, the inner pest, the inner jerk, and all the other monsters who try to talk you out of moving forward-are the part of you that is threatened by change and progress. We all have them. They are trying to protect you from new and scary things, but they are out of sync with you right now and not helpful. They hate what you are doing, but that doesn't make them right.

Keep calm and carry on drawing..

RULe #1:

Ignore all Rules

You're doing it. You're drawing what is right in front of you and y'know what? It looks pretty great.

So now, let's try pushing a bit further. Time to start discovering how little you actually know about the things that are sitting right in front of you. Making art is going to give you a new clarity about things you can't even name, like the reflections off the spout of a coffee pot or the details in a toaster's shadow or the shape of your neighbor's bedroom drapes.

Abstract? Not really. It's *reality*—magical, mysterious, real life. And you almost missed it in your rush to get to your 8 a.m. conference call.

Let's draw.

PLANET CRUMB

First, polish your reading glasses and put in some eyedrops. We're going in deep.

Get a slice of toast and carefully draw its outer edge. Now, pick a section of the toast and look for the smallest thing you can see. A divot, a cranny, a crumb. Draw the shape of that teeny thing. Now move slowly to the very next landmark you come across—another crumb, a bump, a crevice.

Draw it.

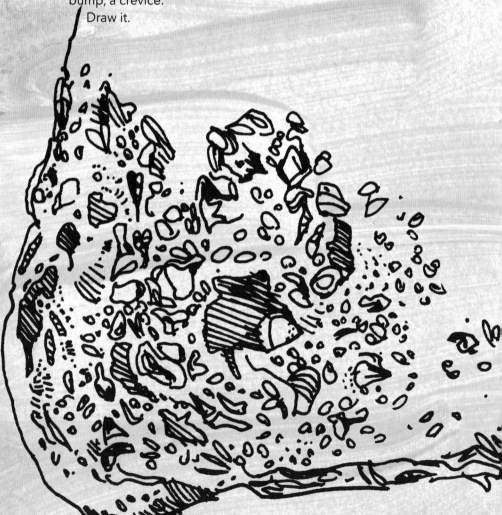

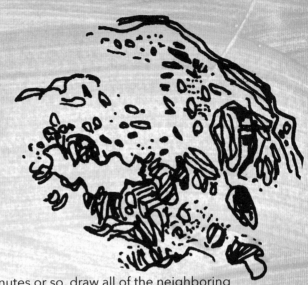

Now, for the next 10 minutes or so, draw all of the neighboring things you see in the toast, hopping from one to the next, as if you were looking out the window of a jet plane and the toast was Kansas. Work your way slowly across it, drawing every single thing you come across. You don't need to fill in the entire outline, just a small section of intense observation will do.

Time's up.
Amazing isn't it, how much was in there? And more amazing still, how peaceful and calm you feel after focusing so intensely on something you usually just cover over with butter and jam.
Now, forget the carbs and eat the toast. You earned it.

AHA! Getting in closer touch with Reality

Our eyeballs are bombarded with enormous amounts of data all day long. To deal with all that input, our brains have developed the ability to process this information and break it down into categories.

So instead of saying, "Look, there's a wooden stick thing covered with bark that's about 45 feet high and has 84 branches and 7,612 leaves in 14 shades of green and is lit from the left at a 60-degree angle," we say, "There's a tree."

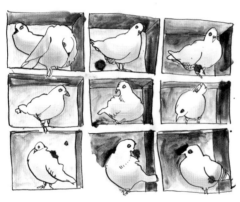

And we look at a bunch of oaks and elms and birches and say "tree, tree, tree." And then we lump all that information into one thing: forest.

Putting things into pigeonholes saves time. But increasingly, it distances us from reality and we start to live entirely in our heads. Life is an amazing epic 3-D IMAX movie but our brains just want to tweet, "It's about aliens 'n' zombies. Lvd it." Efficient but sad.

Reality isn't neat and tidy and compartmentalizable. It has infinite variations and details, and that's what makes it beautiful.

Making art slows us down enough to see the details, the wrinkles, the world within worlds. Without it, life is just a blur of CliffsNotes, movie trailers, and microwaved entrees.

Is that really what you want?

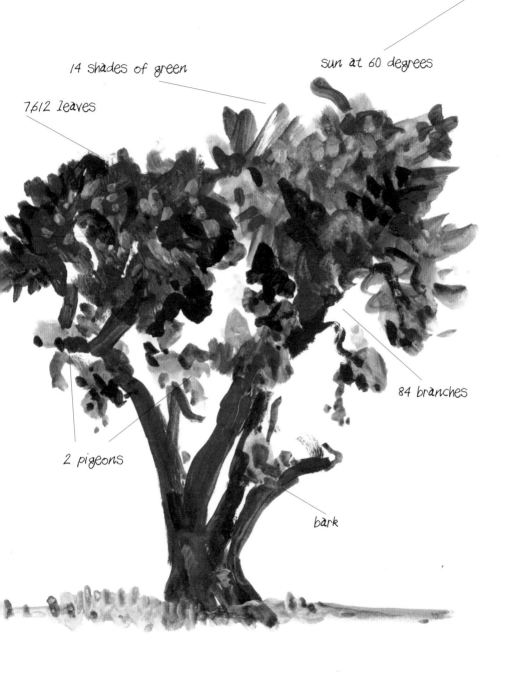

sun at 60 degrees

14 shades of green

7,612 leaves

84 branches

2 pigeons

bark

Remember what da Vinci said

*"Un disegno dieci minuti di pan tostato è un zilione di volte meglio di un disegno a zero minuto di pan tostato."**

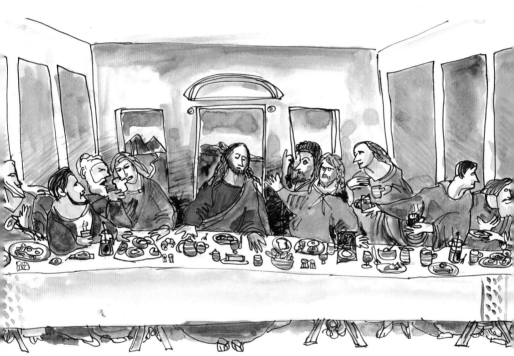

"The Last Breakfast" by Leonardo da Vinci

Little-known fact: Leonardo painted *The Last Supper* while the disciples were waiting for the check.

* "A ten-minute drawing of some toast is a zillion times better than a zero-minute drawing of some toast." And he was a genius.

Shadow Play

In the early morning, the sun is low and the shadows coming through your kitchen window are long. On a fresh page in your journal, draw the shadows cast by your coffee pot, your butter dish, all the things on your table.

 Just draw the shadows. Avoid naming the shapes you draw (No "that's the handle, that's the rim"), and just focus on how strange and unfamiliar many of the shapes are. See them for the first time. And notice how a page of shadows suggests all of the things that cast them but also describes them anew.

Fun House Coffee

Look at the reflection in your coffee pot or your toaster, anything that's chrome or dark glass. Draw that reflection, including yourself and your pen. Copy how everything is bent and distorted, sausage fingers, pea head. Draw the curving walls behind you, the counter beneath. Once again you are seeing the world as it really is, unfamiliar and weird, but through a wide lens that makes it fresh.

A SNOWY MORNING and THE PeRFe OppORtUNi to DRaw amo DRi A NICe wee Potte TeA, iN MY DReSS GowN

Groundhog Day

Pick something you see every morning and usually look past. The street through your kitchen window, a neighbor's roof, an arrangement of jars on a shelf, a lineup of pots. Spend 5 minutes drawing it.

Tomorrow morning, draw the same thing. Do it every day for a week, filling several pages in your journal or just different parts of a single page for more easy comparison. Did you discover more and more each time? Did each day's observations somehow reflect your current state of mind?

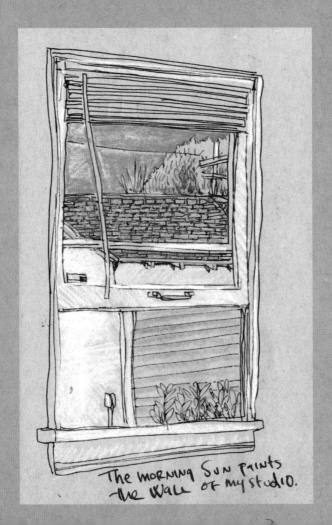

The morning sun paints the wall of my studio.

Be pRacTicaL, not peRfect

Your sketchbook will not be graded, especially not for neatness. Feel free to carry it around with you everywhere and *use it*, put coffee rings on its cover and dog-ear its pages. Use its margins for shopping lists, driving directions, phone numbers, ideas. Make it your constant companion, your wingman.

Aha! BaD dRaWings aRe the BeSt teacHeRs

Every drawing has one great part, maybe just a line or a curve, a record of a moment when we were fully engaged. But we are not looking for perfection; we are seeking mistakes. If you somehow did knock out a perfect, near-photographic drawing, then what? What would it teach you, that hole in one? Would the journey be over?

No, it's the runts, the freaks, the misfits that are our teachers. They let us see how not to see, the price of rushing, the work we still have ahead. And often, our disappointment stems from the fact that we didn't get what we expected. But maybe we got something else just as valuable and we just can't see it yet.

I AM LATE FOR WORK BUT NOT IN THE MOOD SO I AM PLUNKED DOWN ON THE BENCH BY THE DINER ENJOYING THE FREAKISHLY NICE WEATHER OF THIS AUTUMNAL MORNING. MAYBE I'LL GET SOME JAVA

Embrace the drawings that didn't turn out as you'd hoped. Don't rip them out of your sketchbook or write disparaging comments in their margins. Keep them in a special place and look at them later, much later. One day, you will see their beauty and their truth. And remember the 100 percent money-back guarantee I offer: It does get better.

And, finally, if you are cursed with a long spate of perfect drawing, just keep going. Even if today was a perfect day, wouldn't you still want to have tomorrow?

Every day contains a thousand little servings of free time you might just have overlooked. And each moment contains beauty, wonder, and models you never need to pay.

Four-Star Drawing

Restaurants can be expensive—get your money's worth. While you're waiting for your appetizer, don't eat the bread sticks, draw the objects on the table instead.

Draw the waitstaff. Draw the other diners. Draw each dish before you eat it. Draw your bored companion.

Peek into the kitchen and draw the chef, the stove, the health code violations.

Draw the bill and the tip.

Write down a mini review of the evening.

It's a meal you'll never forget.

BACON · EGGS and SAUSAGE

BAGELS · HERB C

CROISSANT · DANISH

CANTELOUPE · PI

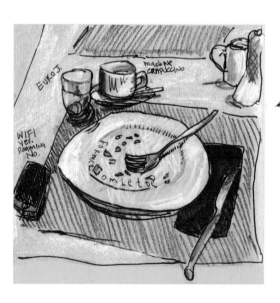

EUKOJ.

machine CAPPUCCINO

WIFI
YES.
ROAMING
No.

FO RICE
omlette

BLUEBERRY YOGURT

HOGGING OUT
at THE BREAKFAST
BUFFET. ARIZONA
BILTMORE

FRANK LLOYD WRIGHT DESIGNED THE HOTE
ano, KNOWING FRANK, DESIGNED THE
FURNITURE, RUGS and DRAPES Too. TH
RESTAURANT WAS NAMED AFTER WI
and APPARENTLY he MAKES THE CRO
ano MANDATES THE DIMENSIONS OF TH
MELON CUBES. COME to THINK OF IT
the CROISSANTS DO RESEMBLE THE GUG

The art of the Couch Potato

Did you know that the average hour of network TV contains 21:51 minutes of commercials? That's valuable drawing time! So, when your favorite show pauses for a commercial break, hit the remote and freeze your DVR. Draw in your sketchbook whatever image comes up on the screen. Could be a car on a mountain road, a guy holding a cell phone, a model with implausibly shiny hair.

Then fast-forward through the commercials (as an advertising professional I say this with a lump in my throat, BTW) and resume watching the show without irritating your co-viewers. There are at least five such opportunities every hour.

Opportunistic Art

Keep some crayons in a jar by the phone. Keep a small sketchbook in your glove compartment. A pen in your purse. An easel by the toilet. Every day has a dozen dull moments—fill each one with a quick sketch.

A dozen sketches a day means that in ten years you'll have done 43,829 drawings.

Then you'll be getting somewhere.

SITTING BY THE POOL, I TOOK A SIP FROM MY SODA AND FELT SOMETHING BRUSH MY LIPS — THEN A BIG, FAT WASP FLEW OUT OF THE CAN.

TART

Two-minute genius

For the severely time-challenged.

A page filled with lots of (even lousy) drawings somehow looks pretty dang good. Divide a page in your sketchbook into a dozen or more squares. Take just 2 minutes a day to draw anything you see in one of these squares. In a week or two, you'll have a gorgeous page filled with a variety of tiny drawn moments. So gorgeous, it's infectious. It'll make you want to fill more and more squares every day.

NDWICH IN THE PARK w/ DS. OVERCAST and EMPTY.

10⁰⁰ FINISHED A BLOGPOST AT MY DESK. SURPRISE ON FACEBOOK FROM KBR. SLOW DOWN. Yo.

12⁰⁰ BRUNCH w/ ROE, JN, TOM, MELANIE + J. TOOK PHOTOBOOTH PIX IAT BLEECKER BAR.

2⁰⁰ BATH FOR TIM and JOE. J BLOWDRIES THEM IN THEIR BEDS.

DING MY KINDLE and A NICE NAP ON the SOFA.

6⁰⁰ EDITING A COMMERCIAL AND DISCUSSING OUR PLANS FOR DINNER.

8⁰⁰ THE ROSES TODD GAVE JENNY ARE ALL WILTING. STILL LOVELY.

10⁰⁰ Jack + GABBY ARE WATCHING 'TRUE BLOOD' I'M READY FOR BED.

Or just draw each day on a Post-it and stick the whole collection in your book.

A FEATHERED ONLOOKER AT OUR DINNER AT THE BLACK HAWK GRILL

Top ten List

I believe David Letterman came up with this exercise. Divide your page into a bunch of boxes and think of a subject that matters to you. Favorite sandwiches. Christmas. Your family. Your car. Your home. Your body. Now, either from observation or your imagination, draw ten things you like in this topic.

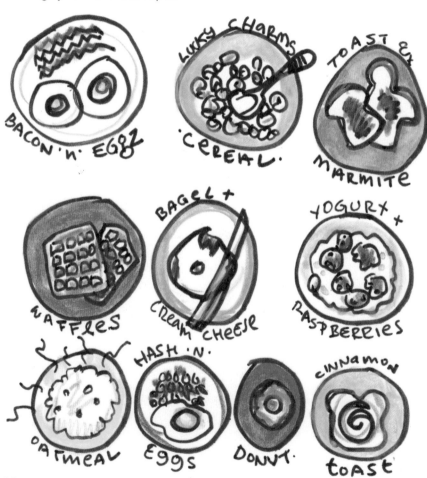

All the News that's fit to Draw

Studies claim that the average reader spends 22 minutes with the daily paper. What if you used that time to draw the paper instead? You're probably missing only depressing news anyway.

The WORLD is your SketchBook

Draw on anything at hand. A newspaper, place mat, receipt, boarding pass, inside of a package, gum wrapper, etc.

Bumper-to-Bumper Opportunity

Draw your car's dashboard. Draw the view in your side mirror, the other cars waiting at the drive-thru ahead of you, the traffic light, the dead bugs on your windshield, the clouds passing overhead. And if you want to remember where you parked, draw your space.

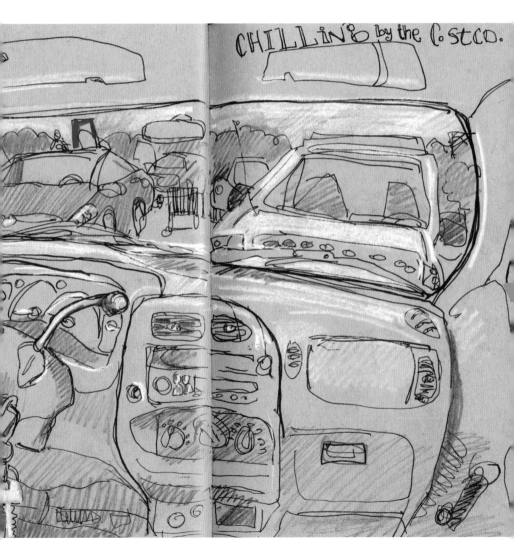

wheN thiNgs get haiRy

Your pets are living, breathing models and they spend all day just striking poses and waiting to be drawn.

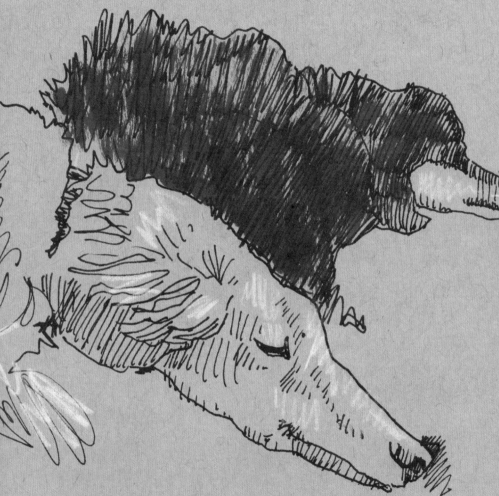

Draw your schnauzer sleeping, your Siamese cat looking out the window, your Airedale eating brunch, your toucan cursing the neighbors, your dachshund wistfully begging for bacon.

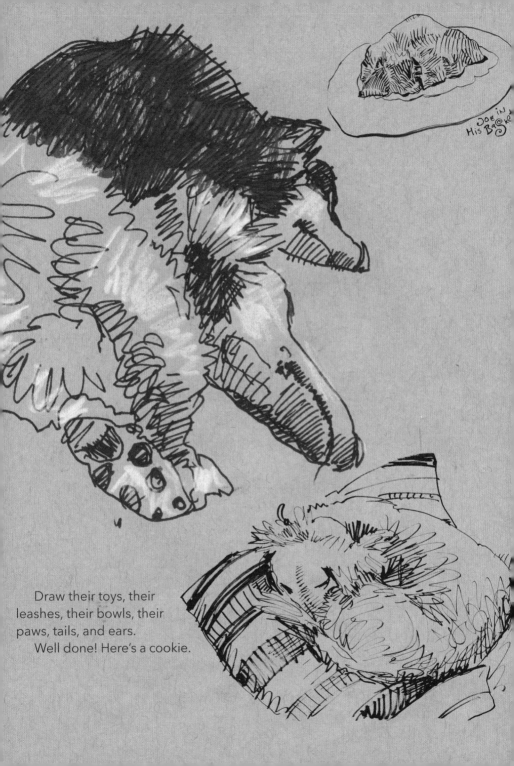

Draw their toys, their
leashes, their bowls, their
paws, tails, and ears.
Well done! Here's a cookie.

Aunt Jemima & Mr. Clean

Sure, you could clean your house. But you could also just draw your cleaning products. Draw your unmade beds, dirty dishes, the crumbs on your counter, the empty juice carton left in the fridge, your own reflection behind the streaks on your bathroom mirror.

It'll all just get dirty again—but art is forever.

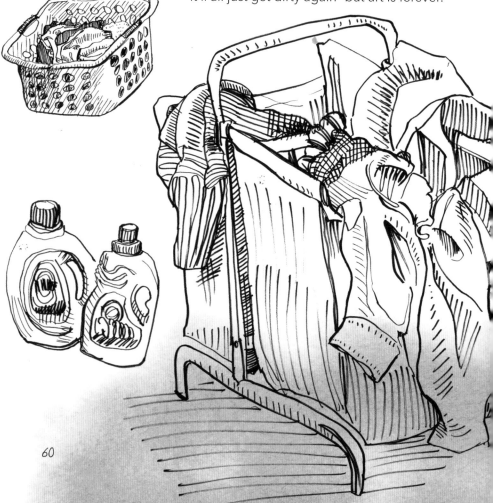

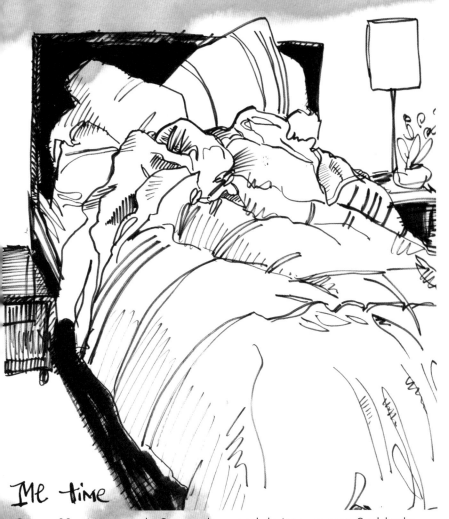

Me time

Get up 23 minutes early. Set an alarm and do it tomorrow. Suddenly you'll have this little chunk of time to use for yourself. Draw something, anything, before the others get up.

 The first thing in the morning is when your brain is clear and optimistic. You'll see better and like what you did more. When your second alarm goes off at the regular time, you can proceed guilt-free with a little smile on your creative face.

Make the best art in the Museum

Pick out a painting and sketch its composition. Copy down some facts about the artist from the signs on the wall. Add to the facts with your own opinions. Make some notes on what makes it good. Or bad. Make quick thumbnails of a half dozen works and see if you can find similarities. Draw a detail, a Roman nose, Jesus' finger, a cute kitty. Draw other people looking at art or looking bored and tired.

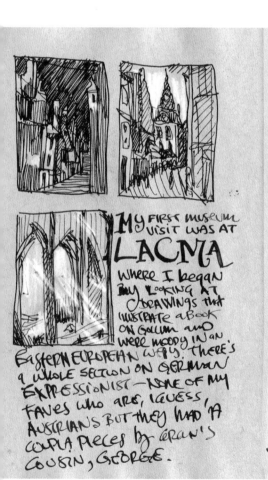

MY FIRST MUSEUM VISIT WAS AT **LACMA** WHERE I began MY LOOKING AT DRAWINGS that ILLUSTRATE a BOOK ON GOLLUM and WERE MOODY IN an WAY. THERE'S a WHOLE SECTION ON GERMAN EXPRESSIONIST—NONE OF MY FAVES WHO aRE, I GUESS, AUSTRIANS BUT THEY HAD 'A COUPLA PIECES by ERAN'S COUSIN, GEORGE.

I DIG MODIGLIA they now a LOVELY LADY w BLUE # ORANGE cheeks CRIMSON LIPS. But Roc

EDWARD *hopper* said he made this painting to SHOW the FEELING of what it was like in a Cheap restaurant — this joint looks pretty nice to me but perhaps it was the depression ERA version of McDs on some such. But actually in those days any meal in a restaurant was probably pretty for Most Folks

im and to P wa they f Bou

"r WI

TABLE I da

D ASLEED. 1656

YOUNG WOMAN + A WATER PITCHER · 1662

WOMAN WITH LUTE. 1662

ERMEER.

DESPITE all the learned curators writing about Johannes' work only I noticed that each of his anvases have a little arrow pointing at the subject ➤

STILL LIFE WITH APPLES AND A POT OF PRIMROSES

THE MET saw fit to comment MAINLY ON the fact that

PAUL CÉZANNE

RAREly PAINTED FLOWERS & PLANTS because they tended to wilt before he was done.

JRE IMPRESSED by the way that 'he

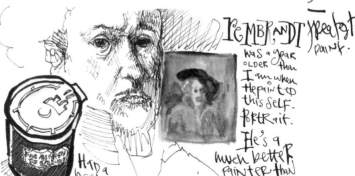

REMBRANDT greatest paint.

WAS a year OLDER than I am when He painted this SELF-PORTRAIT.

He's a much better PAINTER than I am. But I think I'm

E depicts every—
is so-called loneliness

Had a nasty cup of coffee on the steps of the MET.

COMPASS POINTS

This is a good one to do in your cubicle. Draw whatever is directly in front of you in a strip across the top of your page. Then swivel 90 degrees clockwise. Draw this new scene below it. Repeat until you have come full circle. Hopefully the landscape varies.

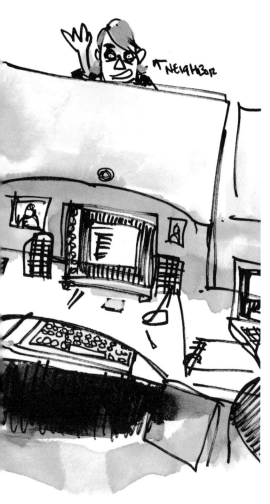

Extra credit: Draw the whole 360 degrees as one long, continuous drawing that connects back up with its beginning at the end.

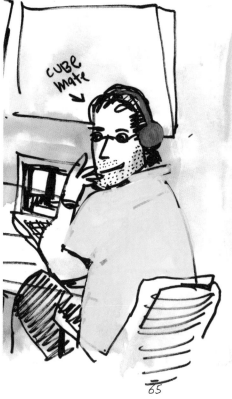

Airports

Pray that your flight is delayed. Then you can draw other passengers napping or reading books. You can spend time really looking at the outside of your plane (any cracks?), at all those weird vehicles trundling around on the tarmac, at the lady who sells gum, at the guy ordering a Jack Daniel's at 7 a.m. It's much better and cheaper to *draw* all the shelves of trashy magazines and paperbacks in the store than waste time and money *reading* even one.

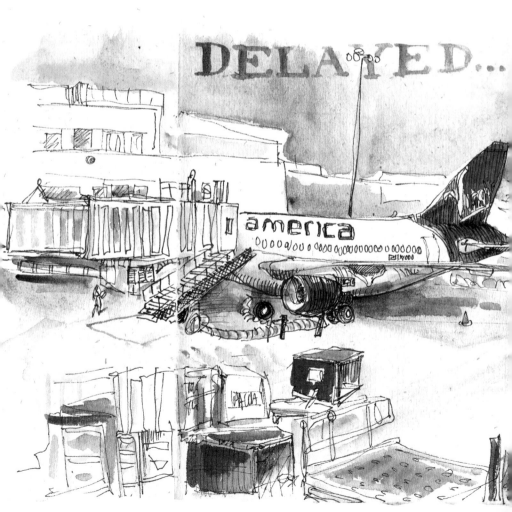

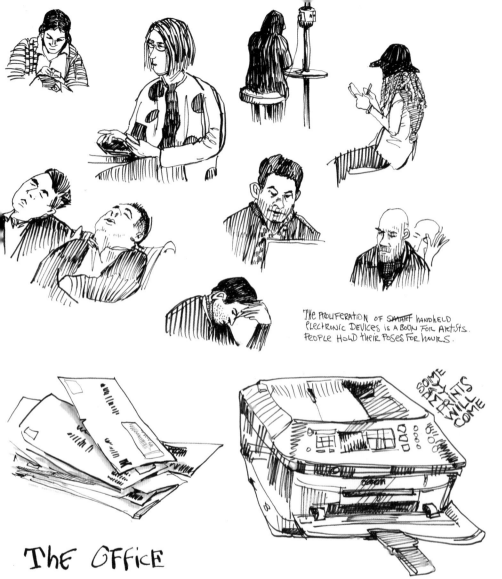

THE PROLIFERATION OF SMART handheld ELECTRONIC DEVICES IS A BOON FOR ARTISTS. PEOPLE HOLD THEIR POSES FOR hours.

SOME DAY PRINTS WILL COME

THE OFFICE

This is risky but fun. Draw in meetings. Draw your colleagues, the speakerphone, the clock on the wall. Draw the products you make or sell. Draw your customers. Draw smokers outside the building. Draw the time clock, your tools, your boss (if you dare).

It's high time you were more productive at work, so start drawing!

How Duchamp got his start

Draw while you're on the toilet. Draw the towels, the sink, your feet, the view down the hall. Draw on toilet paper. Or keep a handy bathroom sketchpad. Wash your hands after drawing. (These drawings may not be for sharing. Or they could establish you as an important contemporary artist.)

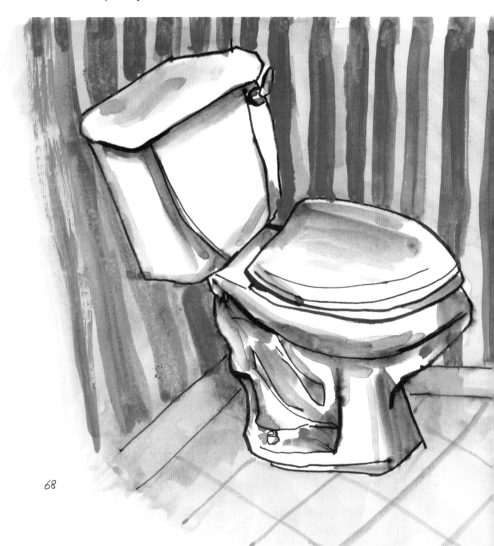

AHA! MOR-on Mistakes

Can you really not live with the "mistake" you just made in your sketchbook? The one line that seems slightly wrong, the drip of ink, the smudge? Think about it this way: Mistakes are lessons in disguise and accurate reflections of your true state. Maybe you need to slow down. Maybe your initial expectation was actually what was wrong. Maybe you need to draw more often.

 If you really can't live with it, fix it artistically. Paint over it with some opaque gouache. Or redraw something on top, like someone correcting a bad tattoo. Take a glue stick and cover it with some ephemera that tells a story, a bus ticket, a credit card bill, a map of the neighborhood. Last resort: Tape the offending pages together along the edges. Later you (or a museum archivist) can open it up again and learn from your "mistake" which may actually turn out to be charming and great.

Backyards aren't Just For Mowing

Commune with nature. Take your lunch break in the park. Breathe the air, listen to the birds, feel the sun on your face. Draw a flower, a bird, a hill covered with the first daffodils of spring. Draw clouds, waves, sunsets.

TRADER JOE'S MOST PUNGENT

FReeSia.

YaRDBiRDS we all love hanging

at your garden on a sunny Saturday afternoon, reading, napping.

70

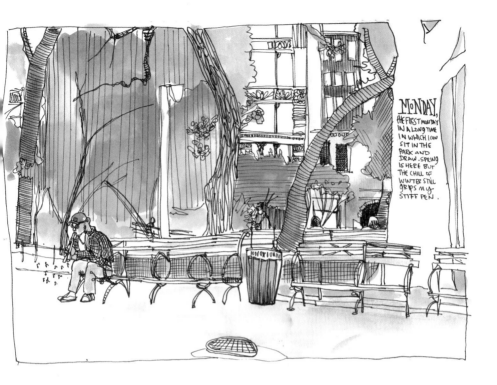

MONDAY, THE FIRST MONDAY IN A LONG TIME IN WHICH I CAN SIT IN THE PARK AND DRAW. SPRING IS HERE BUT THE CHILL OF WINTER STILL GRIPS MY STIFF PEN.

Make it a habit: Observe the changes of the seasons by drawing the same view every month for a year. Write down what you see and feel. Be in the moment.

ROSEMARY: SMELLY LITTLE CHRISTMAS TREES.

MINT: BUBBLY and BLISTERY, WHITISH GREEN WITH YELLOWISH CREVICES. SMELLS DISTRACTINGLY GOOD.

PARSLEY

WHITISH STEMS

KALE: CRINKLY LEAVES MUCH LIGHTER THAN WHEN RIPE.

LETTUCE: A SALAD-IN-WAITING. JUST BRUSH OFF THE CHICKEN MANURE AND ROLL OUT THE BALSAMIC.

BRUSSELS SPROUTS: RIGHT NOW, EACH PLANT IS JUST 4 CARTOON SPADE FINGERS. SOON THEY'LL SPROUT SPROUTS.

Leaves I have grown.

Child's Play

Draw your kids while they are busy. Draw them playing a board game or watching TV. Engrossed in an iPad or, better yet, a good book. Eating the dinner you cooked, veggies and all. Taking a nap. Draw them drawing!

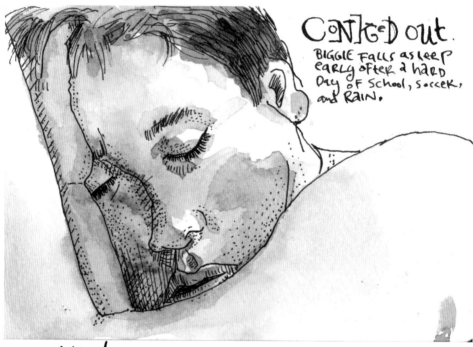

Conked out.
Biggie falls asleep early after a hard day of school, soccer, and rain.

Aha! Calling all Kids

When you were little, you made art all the time. Remember? Crayons, finger paint, poster paint, chalk, papier-mache, Play-Doh. You sang. You danced. You dressed up. Your imagination was your constant companion. And all your friends shared in your art. You lived in an artists' cooperative.

Everyone around you was supportive. Mom, Dad, teachers celebrated

the art of childhood

Draw with a child—your own or one you've borrowed. Draw with crayons, tempera, pastels, finger paints. Interact with your drawing partner. Take requests. Tell a story and illustrate it as you go. Or you draw a line in red, she draws one in blue, back and forth till it looks cool. Ask your kid to draw a crazy line and you add to it to make an elephant or a choo-choo or a ham sandwich.

Scribble.
Splatter.
Play.

For a few minutes, let go and be a child.

Finn

your work, saved it, pinned it up, stuck it on the fridge. You were a star.

Why does that have to be just a distant memory? Why can't you have that same spirit of creativity, brave exploration, open-eyed wonder—even for just 10 minutes a day?

That little artist is still in there, inside you. Get that kid some crayons.

Variations on A theme

Pick a topic and draw a number of things around that theme on the same page or two.

Draw every different type of spoon in your kitchen—from teaspoons to ladles.

Draw your cat striking six different poses.

Draw all the cars on your block.

Draw every bill in your wallet.

Draw every hair style you've ever had—use old photos or your memory.

Draw each of your fingers and toes, separately and in great detail.

Notice the similarities and the differences among the obects. Label them and write notes on what you learned, or where the objects came from, or how you feel about the category, or what makes one or another your favorite.

Draw down your debt

Draw your monthly bills. Draw the envelopes, the contents. You don't need to copy every word and number, but just capture the spirit of each one. It'll make you think twice when you next pull out your credit card (except in art supply stores, which is always okay).

Conspicuous Consumption

Draw anything you buy. Anything. Groceries, plasma TVs, diamond engagement rings. Just a quick little sketch, and label it if you want. Remember, drawings last longer than food, TV shows, and many relationships.*

> * To see this taken to an extreme, check out KateBingamanBurt.com. She changed her whole financial life and credit rating by just drawing everything she ever bought.

Live healthy and creative

Draw on the treadmill. Draw your trainer. Sketch between sets. At the end of yoga class. (But not in the locker room.)

Take a hike!

On your lunch break, walk at a healthy pace for 13 minutes. Stop. Draw your location for 4 minutes. Walk back. Repeat three times a week until your sketchbook is full and your stomach is flat.

You are what you eat

Draw every single thing you eat each day. You'll find that you eat slower and you eat less (because your food is usually cold). Soon you'll find yourself asking, "Do I really need to draw this donut?" You'll be amazingly skinny and way cooler. Trust me, it works.

Think about it: Why do they call them *"starving artists"*?

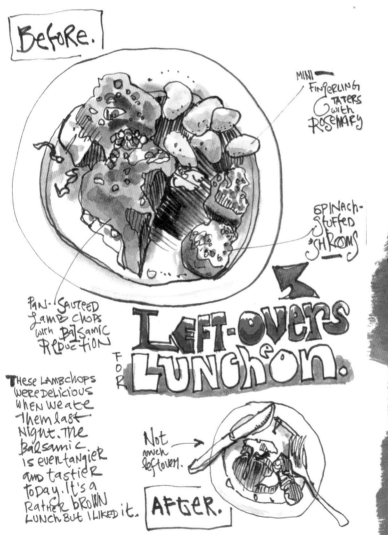

Before.

MINI FINGERLING TATERS with ROSEMARY

SPINACH-STUFFED 'SHROOMS

PAN-SAUTEED LAMB CHOPS with BALSAMIC REDUCTION

Left-overs FOR Lunchon.

These LAMBCHOPS were DELICIOUS WHEN WE ATE THEM last NIGHT. THE BALSAMIC is even TANGIER and tastier TODAY. It's a RATHER BROWN LUNCH but I LIKED it.

Not much leftover.

AFTER.

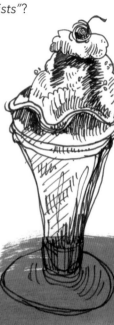

Sundae painter

Be the one to skip dessert. Instead draw what everyone else ordered. Draw their love handles. Remember, ink has no calories. Zero.

aHa! Obstacles

How are things going? Are you getting in the creative habit? Are you making enough time for yourself? Do you need a pep talk?

There are obstacles that get in the way of every artist's work. You can be going along like gangbusters, drawing in every spare moment, and then one day you wake up and you just don't wanna. That's fine and it's part of the process. The fact that you hit a wall doesn't mean it's over, that you've failed. Your brain and your soul are letting you know that you need to take a break to recharge, that's all. Listen to them. And keep listening. Change course and look at other artists' work instead of drawing. Or watch a movie about a musician's life (like Amadeus). Or cook something. Or just veg out.

But keep listening. Don't take the fact that you have paused as an indication that you have lost the habit. Just keep your book and pen around and pick it up when the urge returns. It will. Wait-here it comes!

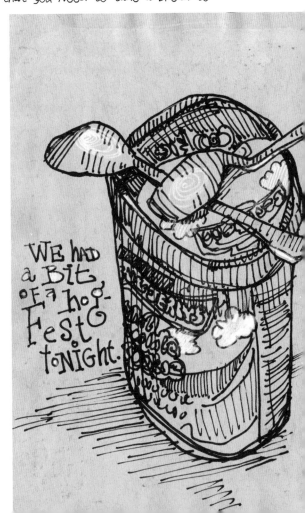

BeYond Black & White

Now that you've drawn everything that moves, let's get your pen a back-up band. Some brushes, some colors, some other ways to see the world in all its polychromatic glory. Soon your sketchbook will be ablaze with color.

the 15-minute colored pencil lesson

Colored pencils are a great first step in adding color to your drawings. They're portable, affordable, unmessy and you've probably used them before (but maybe not since you were seven).

The most obvious way to use colored pencils is to simply fill in your drawn shapes with solid colors. That can make for a nice graphic look, but it doesn't allow you to capture the zillions of tones and shades that you see.

Try drawing in ink and then adding color with your pencils. Then do a whole drawing, lines and all, in colored pencil.

Layering: You can mix new colors by putting one shade on top of another. You can also feather or blend one into another. Even a small set of colored pencils can give you an enormous range.

Toning: Vary the pressure you use. Try pressing very hard for bright, rich colors that attract your eye to certain parts of the drawing. And then back off until you get faint, delicate pastels to color the background. Try different approaches to reflect the light, atmosphere, subject matter or just the mood you're in.

Colored ground: Try drawing in colored pencils on colored drawing paper or construction paper. I love to draw with whites and pale colors on dark or gray paper.

83

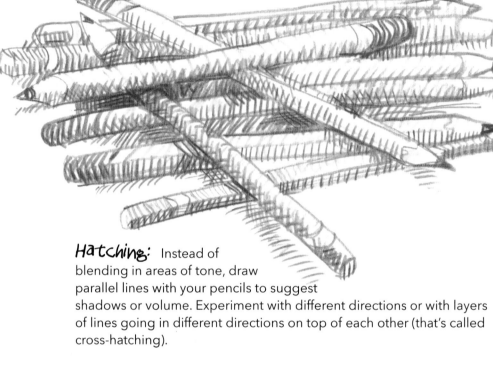

Hatching: Instead of blending in areas of tone, draw parallel lines with your pencils to suggest shadows or volume. Experiment with different directions or with layers of lines going in different directions on top of each other (that's called cross-hatching).

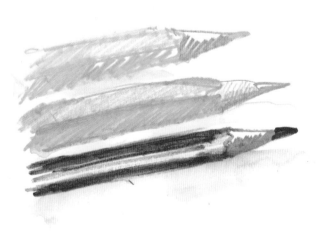

Water: Try some watercolor pencils. These are often creamy, bright colors that you can then go over with a clean wet brush to turn parts of your tinted area into pure watercolors. You can also dip your pencils into water and then draw with them for an even smoother, brighter effect.

The 15-minute watercolor Lesson

Watercolor is daunting to many people. It needn't be. It's the perfect medium to combine with ink lines and has the most expressive and flexible colors. You can work quickly with a minimal amount of gear.

But be prepared, the more you get into watercolors, the more there is to learn. Start with basic colors and don't be frustrated if you are surprised by the ways colors mix.

gouache

There are two basic grades of watercolors: student grade, which are cheaper and chalkier, and artist quality, which are more saturated and don't fade over time when exposed to light. The former will do the job; the latter will make you happier (if poorer) in the long run. Start with a basic set with less than a dozen colors. You could also try tempera and gouache, which are more opaque versions of watercolor.

Work light to dark: Watercolors are flexible and changeable. Start with a heavily diluted brush load of your lightest color. Then use progressively darker colors, all diluted, filling areas, until you have covered your page. Then go back to the lighter colors and add details with layers of more intense color. Keep building up the colors, working round the page, until you are done.

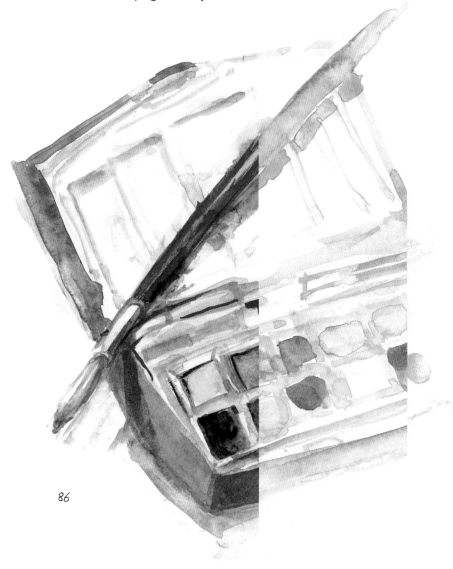

Wet on wet: This makes for gauzy, more abstract colors and shapes—what we think of as "watercolory". It's nice when combined with a line drawing, too. Wet your page a bit. You can paint the whole page with a big soft wet brush, daub it with a wet paper towel or sponge, or just carefully pour some water directly on it. (This works best if you have heavier paper or, ideally, watercolor paper in your book.) Then drop some watercolor on it and watch it ooze out into spidery waves. Push it around. Add more colors if you want, or wait 5 minutes for it to dry, then add some more hues.

Mixing: Start with just the primary colors—red, yellow, and blue—and mix new colors on your palette or directly on the page. Try combining complementary colors (orange + blue, red + green, yellow + purple) to create darker shades or even gray and black. Generally, don't mix more than three colors together, or you could get a muddy brown. You'll notice that different types of the same color can react quite differently. Cadmium colors tend to be overwhelming, for example. Experiment and make lots of educational mistakes.

Salty: Try sprinkling some salt onto a wet watercolor page to attract the pigment for a really cool effect.

Nuclear option: If you can't wait for your watercolors to dry, pop your book in the microwave for a few seconds. Seriously. Just make sure it has no metal parts or you haven't used any gold leaf in it (as I once did), or it could burst into flames. Less dramatic: a hairdryer.

the Ra
Rolled
and twilight
us, vivid and
clear in th
Scrubbed
the Rooftop

Color me blue

Color can be used in so many ways. The most direct way is to reproduce the colors you observe in nature. But a single patch of color in a line drawing can also add a huge amount to the mood and message.

Try prepainting random pages throughout your journal with a single color. Cover an entire page with yellow, then one with red, another with a sepia tone. Later, when you come to those pages, draw on them with an ink line and see how they affect the mood of your drawing. How is a blue page different from a red or yellow one in the way that it makes you feel? Try adding some darker areas of the same tone to add dimension.

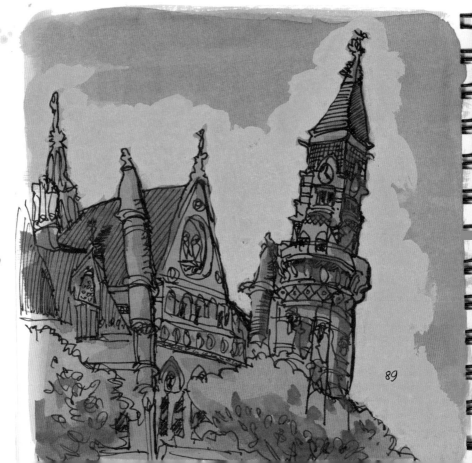

89

Shapes

Paint the shape of an object with a single color. Then draw the details in ink.

Or do the opposite: Fill in one part of a contour-line drawing with color to draw your eye to a detail.

CRAYONS

Crayons make you draw more loosely and wildly, bringing out your inner preschooler.

Keep boxes in convenient places: the kitchen, the coffee table, your cubicle, the glove compartment.

Hold one in a candle flame and draw with it quickly as it melts.

Paint over a crayon drawing with watercolor.

FRiENDS with PeneFits

You don't need to make art alone in a garret. Even smelly old van Gogh had a friend or two.

Here are some ideas for communal art making that are fun and nonthreatening and can involve liquid courage. Even if your friends are all left-brained accountants and lawyers, invite them to join your artists' commune.

How to Draw a Portrait

A portrait is an impression. It's all about the major things that define the person you are drawing. It could be their hairstyle, the shape of their nose, the size of their eyes, their enormous, waxed, handlebar mustache.

Your goal is not to capture their features precisely but to capture their essence, subjectively.

Now, bear in mind, that not every one see others exactly as you do. And that's particularly true of the person you are drawing—people find it very tough to see themselves clearly. So, don't get caught up in how others feel about your portrait, especially as you are drawing. Laugh it off— he *does* have a nose like a rutabaga.

Let's begin by looking at the person for a while. What are they like?

Energetic, stoic, withdrawn, wiry, a lump?

Now, consider the best medium to capture this person. A quick brush painting? Crayons? A smooshy soft pencil? A sharp fine point pen?

Okay, time to draw. Think about the big shapes in your friend's face. The jaw, the overall shape of the

head and hair, the cheeks, the forehead. Lay it down quickly, impressionistically. Maybe do a quick measurement: How wide is their face compared to the distance from chin to eyes? Where is the actual dead center of the face? Where does their neck begin?

Now let's add some features. Think about the shape of the eyes—oval, round, sloped upwards. Quickly draw the general placement

of the eyes, the shape of the nose, the thickness of the lips, the ears.

Now let's refine it all with a new set of lines. And, again look at landmarks. Where is the top of the ears relative to the eyes? To the bottom of the nose? How far from the edge of the outer eye to the hair? Is the mouth wider than the edges of the nostrils?

Don't get crazy with these observations, however. Keep your hand loose, keep it moving. Don't spend more than 5 or 10 minutes on the whole thing.

Now, turn the page and do another one.

95

Selfies

Not to boast, but I'm a supermodel. Actually so are you. The most super compliant, super available model every artist has is himself. That's why artists make so many self-portraits. Rembrandt didn't paint himself over and again because he was a narcissist who thought he was devastatingly handsome, but because his moon face and lumpy nose were always on call.

So if you want to learn how to draw people, start with yourself. Just sit down in front of the mirror and draw what you see. It can be scary. It can drive you to a plastic surgeon. But it will teach you more about who you are and how to draw anyone.

Follow the same rules I gave you for drawing a portrait. Pick a medium that suits your mood, then put down the big shapes and keep working and measuring your way to more detail.

Try yourself from different angles, reflected in distorting mirrors and shiny objects, whatever captures who you are today.

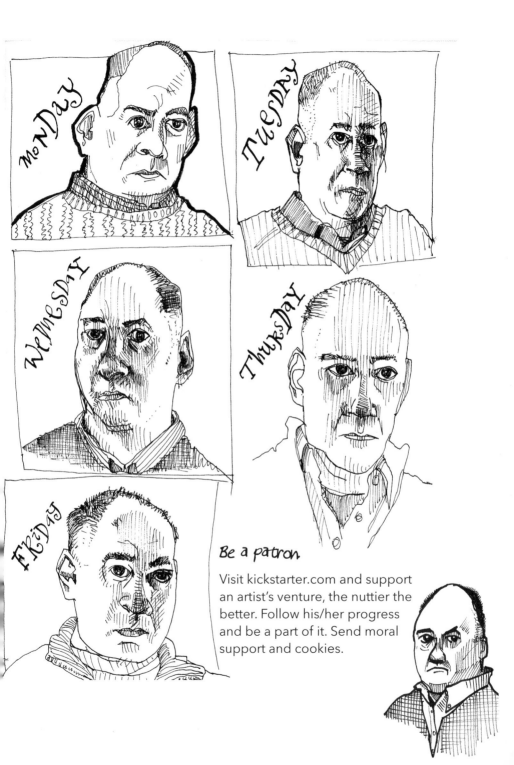

MONDAY

TUESDAY

WEDNESDAY

THURSDAY

FRIDAY

Be a patron

Visit kickstarter.com and support an artist's venture, the nuttier the better. Follow his/her progress and be a part of it. Send moral support and cookies.

Sketchcrawl

Picture a pubcrawl—only with drawing. Get a bunch of friends together. Could be one person, could be a hundred. Then pick a neighborhood or a museum or a park. Settle down together in an area and have everyone spend 10 to 15 minutes drawing anything they see. Then, whistle loudly and get everyone to move somewhere else. Keep doing this until you end the outing in a bar or café. Share your drawings and some laughs. It's great to see how different people see the same place or object; compare styles, POVs, techniques, speed, etc.

Post-it Party

This works well with utter novices. Pick a photo of a celebrity or someone everyone knows well. Blow it up really large on the copier. Make two of these big copies. Tile Post-its across the picture, and cut the pieces into pieces, in sequence, so you end up with a stack of Post-its attached to small squares of the picture. Label each one with a row and column so you can reassemble the picture later.

Don't show the original picture or even the subject to the Post-it partiers. Not yet.

Ask everyone to copy the abstract bit of photo onto their Post-it. After 5 to 10 minutes, gather up all the squares and use your second copy as guide to rebuild the picture out of all the little drawings. Do a big reveal.

This exercise is a great way to inspire people to draw. Point out to them that if they could draw any random square of the image, they could draw all of them.

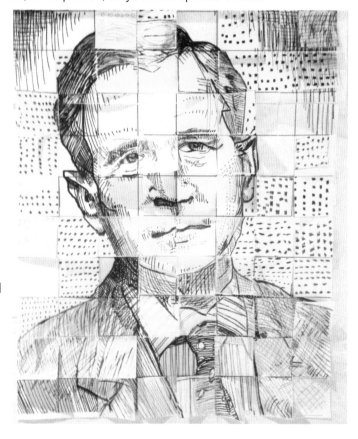

99

Portrait Party

This is like Secret Santa or speed dating. Gather a bunch of friends (ideally in-person, but it can also be fun online).

Each person picks another member of the group to draw, in person or from a photo. Share the results. Laugh at how big everyone's nose is. Mix it up and repeat the next week.

Works best when combined with alcohol. Or LSD.

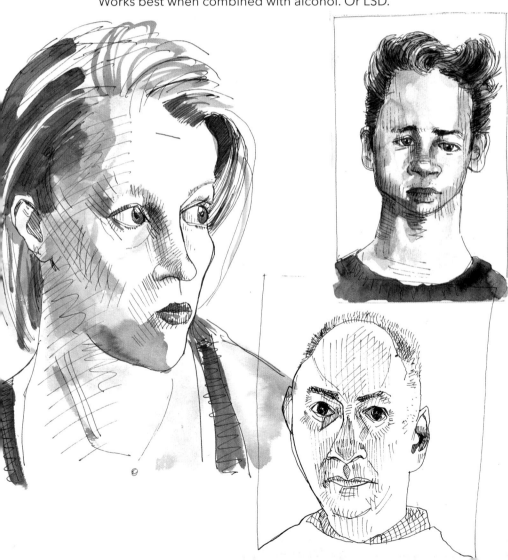

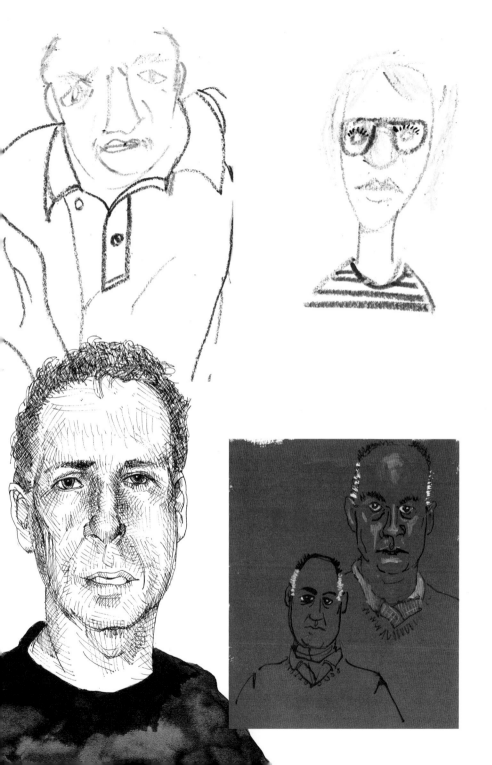

Aha! One thing leads to Another

This book is focused on drawing and painting. But you don't have to be. Try expanding your repertoire to include other art forms that can fit into your daily life.

Keep a harmonica in the shower. Practice a dance move in the elevator. Learn to whistle an entire Mozart sonata. Write a poem about how well your presentation went. Compose a rap song on the subway, then perform it on the platform. Sculpt a nude in your butter dish. Buy three ingredients you've never eaten before and figure out how to cook them together. Shoot a movie with your phone.

Drawing may be just a gateway for your creative life, but do go through it and start making cool stuff!

It's easy to fall into a routine when you draw, using the same materials in the same order, working the same size, drawing only the things you've told yourself you're good at drawing.

Let's mix things up.

Not all media were created equal

Certain media let you move fast, covering the paper quickly, getting your feelings onto paper. Others are not to be found in art stores but are still fun to put on the page.

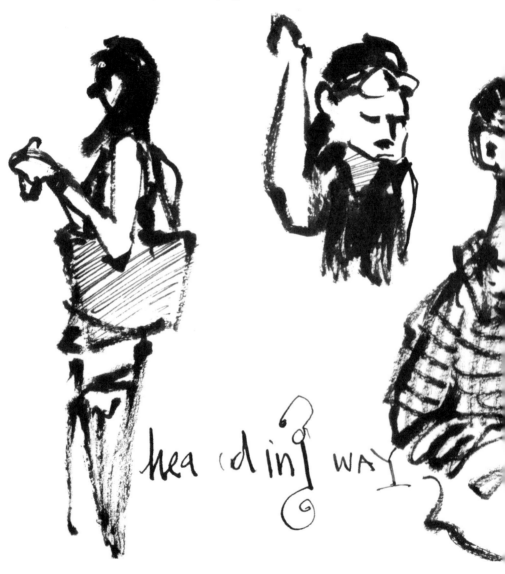

A Brush with Speed

Try drawing with a brush. It's a little less controllable and a bit messier but can be very expressive. Try drawing animals or people walking down the street with a brush or a brush pen. Draw the background with a different medium, a pen or a pencil.

Here's mud in your book

You're picnicking in the park with your book and a pen. Use some of the things that surround you to add color. Coffee, mud, grass, wine.

merlot

cabernet

chardonnay

Draw with lipstick on mirror. It's smooth, creamy, and not just for love notes. Comes right off with Windex. If you like doing this, you can get some of the same feeling from drawing with pastels, china markers, or fat markers on paper.

57 varieties of art. You've got some extra ketchup on your plate. Draw something with your finger. Or a French fry. An abstraction, a portrait, some cross-hatching.

ketchup

ak sauce

mustard

Laurel and Hardy

Try drawing with a fat pen first, big sweeping lines that capture the essence of the thing. Then go in with a thin pen and add details and shading. Or draw things that are closer with a fat nib, and draw things in the distance with a narrow one.

111

A Sinister idea

Sinister means *left* in Latin. So if you're a righty, maybe you'll tap into your dark side by switching hands. It will feel awkward and clumsy, but keep going. You will find a new looseness and a different line quality that can be really fresh and exciting. Obviously, if you're already a lefty, switch to the right hand. And if you're ambidextrous, hold the pen between your teeth or your toes(!).

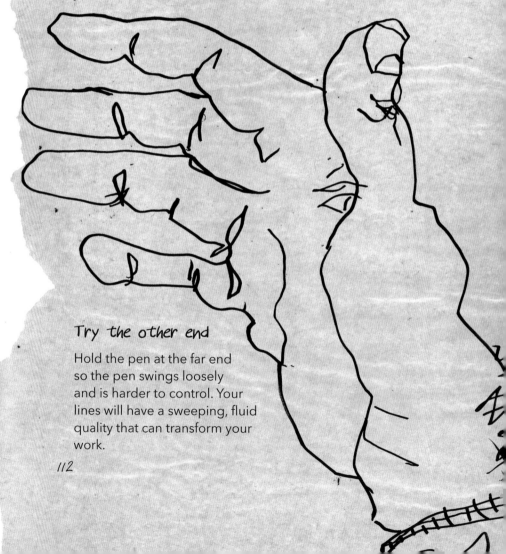

Try the other end

Hold the pen at the far end so the pen swings loosely and is harder to control. Your lines will have a sweeping, fluid quality that can transform your work.

aha! Perfection

What happens when you get so fixated on perfection that you never begin? Never begin drawing. Never begin making stuff. Never begin pursuing any sort of passion for fear of not being able to do it incredibly well. Nothing you do will be good enough even for you. Why bother if you can't be great?

CAN I PLAY?

 A variation of this behaviour is fiddliness. Constant reappraisal, erasing, tweaking, reconsidering. Taking your drawing into Photoshop and cleaning it up, coloring it, recoloring it, sharing ten versions of it, asking for comments, on and on. Never done, never good enough.

 One of the problems with perfectionism is that you think you can conceive the destination before you embark on the journey, that you can plan it all out in advance, and that nothing else can intrude and change the outcome you have conceived. But, first of all, the world doesn't work that way. Unless you are doing something extremely simple and banal, something you can actually hold in your brain all at once, it will invariably intrude and change your well-laid plans.

 And, second, you should welcome that intrusion. The accidents, mistakes, serendipities, and ink splatters that the universe throws in your path make your work and your life more interesting. Perfection isn't organic. It's constipated, lifeless, and dull.

"Perfectionism is the voice of the oppressor, the enemy of the people. It will keep you cramped and insane your whole life."
 -Anne Lamott, *Bird by Bird*

Double Take

If a scene catches your eye but time is short, break it up into a couple of stages. Draw the object today and then come back tomorrow and draw the surroundings. It could also make for an interesting contrast as your mood shifts from one day to the next.

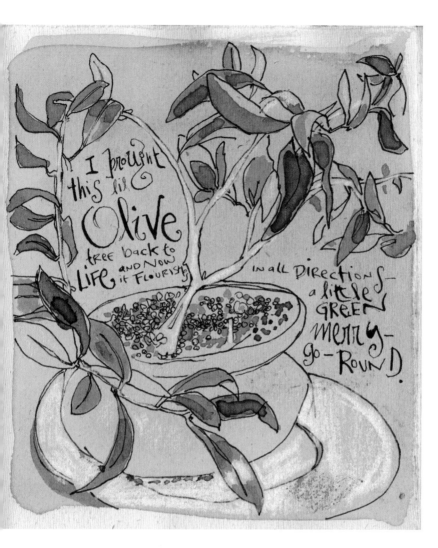

The drawing contains the following handwritten text:

I brought this lil Olive tree back to LIFE, AND NOW it FLOURISH IN all DiRections — a little GREEN merry-go-RounD.

Refresh your work

Take a drawing you did a few weeks ago, one that could use a second look. Add some watercolor washes, or color in some sections with a pencil or two. Expand the caption you wrote. Draw something else around or behind your original drawing. Keep it alive!

Build a Media Empire

There's no rule that says you have to stick to a single type of art supply. Think of your artwork as a sumptuous, multi-course feast.

Start with an ink line drawing that records your observations. Then add a layer of watercolor right over the drawing to add tone (make sure you used India ink or a waterproof pen). Then add details and emphasis with colored pencils, markers, even crayons. Now write a caption with a fountain pen. Add a title with collaged words from a magazine or rubber stamp letters. Mix it up!

Take two

First draw an object loosely with a brush in diluted ink. Move quickly, capturing your general impressions. Your lines should be rough, sweeping approximations.

Now get a fine pen. Slowly and carefully draw the same object on top of the brush marks. Use the fine black lines to add detail.

This combination of energy and observation makes for a drawing that's both fresh and full of information.

Keep switching

Draw every single line in a drawing with a different color or medium.

Aha! Fire your inner critic

Imagine if you signed up for a drawing class and from day one, the teacher hung over your shoulder and harangued your every move. Imagine if she told you you can't draw and will never be able to, told you to just forget the whole thing. Imagine if she constantly chipped away at your confidence, your personality, your self-worth, turning a simple drawing exercise into a judgment on you as a person. You'd drop the class and ask for your money back, right?

Your inner critic can be just that sort of nightmarish voice in your head. And the fact is, that voice is wrong. Every drawing you do has some value. It teaches you new and valuable things. And it is vital to realize that the moment when you finish a drawing is not the time to judge it, not the time to learn the full value of the lesson.

hippo.

When you sit down to do a drawing, you have an expectation in mind, a reason for choosing this subject, medium, POV. As you draw, you may drift away from that original goal. You may work faster than you should and lose your concentration. One inaccurate line may move your drawing in a new direction. So finally, when you look at what you have just done, it no longer fits with your original plan. That disappoints you and you take it out on the drawing you have made. But the fact is, this drawing may well be an interesting and beautiful one—just not in the way you anticipated.

That's why you need to (a) ignore the inner critic and just keep on drawing, reminding yourself that if you don't keep working, you'll never make progress and (b) when you are done, turn the page and come back to this drawing in an hour or a year.

Don't judge yourself harshly. Enjoy the process (and you will if you can just stay in the moment, rather than constantly stepping back to evaluate your every move). And never, ever rip a page out of your book.

Time is short. Don't waste it beating yourself up.

Keep drawing.

Be kind to you.

"If you hear a voice within you say 'you cannot paint,' then by all means paint, and that voice will be silenced."
— Vincent van Gogh

THe WeeK oF LiViNG aRtFUL1y

If you want to go beyond quick sketching, do a piece over the course of a week by adding more detail or additional media each day. Draw your outline on Monday. Then add tone on Tuesday, shading on Wednesday, a border on Thursday, a caption on Friday, and so on. Each step may take you only 10 minutes or so, but the final result will be rich and deep.

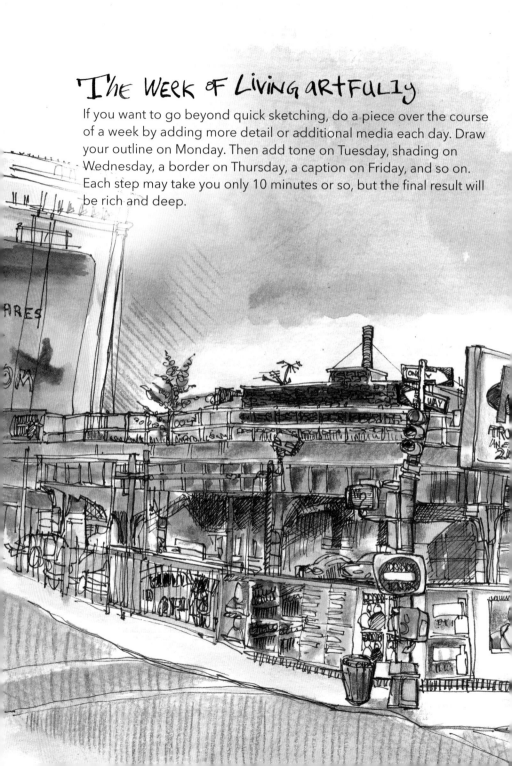

Water Surprise

Do a drawing with a water-soluble pen. (This can be a great way to start working with the springy flexible line of a fountain pen.) When it's dry, wash over parts of your drawing with a damp watercolor brush. You could make the lines bleed and cry or wash out big areas of tone. Notice how the color changes as the water hits it, creating blues and purples out of black lines. Be prepared for surprises. Stay loose.

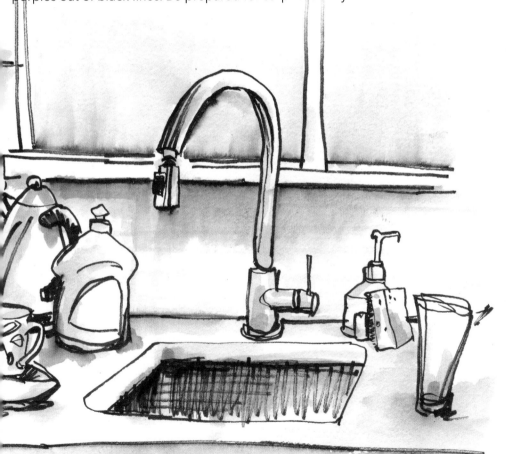

123

Hatching—it's not just for chickens

Drawing black lines on white paper is great if you want to indicate the shape of things. But what if you want to add tone to indicate what materials the object is made of, or shading to give dimension and indicate shadow and light?

Ta-da! Introducing "hatching," parallel lines that fool the eye into thinking they are shades of gray.

It's a very flexible tool with all sorts of fun variations.

You can space your lines exactly evenly for a uniform shade; closer lines are darker, wider distances make a lighter gray. Think pinstripes, chalk stripes, etc.

You can vary the spacing to make a gradual transition of tone.

Try "cross-hatching" with a second layer of lines in a different direction to add a darker shade or a change in intensity.

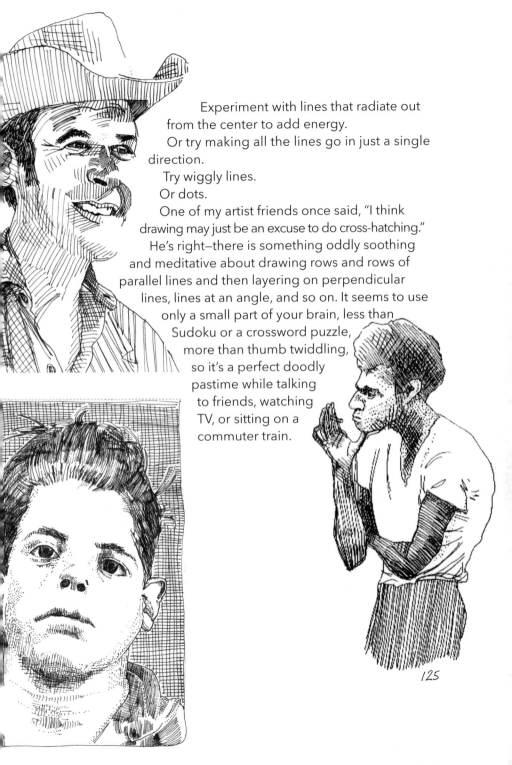

Experiment with lines that radiate out from the center to add energy.

Or try making all the lines go in just a single direction.

Try wiggly lines.

Or dots.

One of my artist friends once said, "I think drawing may just be an excuse to do cross-hatching." He's right—there is something oddly soothing and meditative about drawing rows and rows of parallel lines and then layering on perpendicular lines, lines at an angle, and so on. It seems to use only a small part of your brain, less than Sudoku or a crossword puzzle, more than thumb twiddling, so it's a perfect doodly pastime while talking to friends, watching TV, or sitting on a commuter train.

125

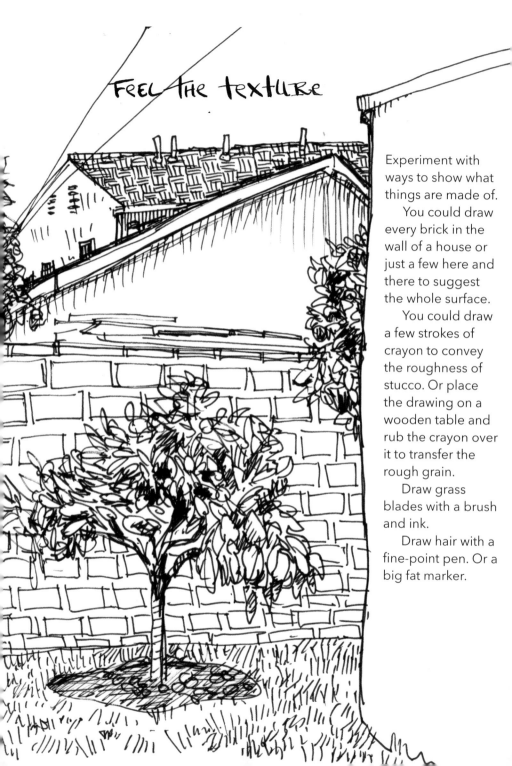

FeeL the texture

Experiment with ways to show what things are made of.

You could draw every brick in the wall of a house or just a few here and there to suggest the whole surface.

You could draw a few strokes of crayon to convey the roughness of stucco. Or place the drawing on a wooden table and rub the crayon over it to transfer the rough grain.

Draw grass blades with a brush and ink.

Draw hair with a fine-point pen. Or a big fat marker.

WRITING is DRAWING.

There are so many ways to represent letters, and each approach adds an accent to the words. Fonts can be formal or playful, warm or austere, modern or traditional. The same can be true of hand-lettering.

Fill a page with words. Draw some with a pen, a brush, a crayon. Try using a steel calligraphy nib dipped into a bottle of ink.

Try a big word or two as a headline, then write columns of words that are small and regular.

Print out a page of words in different fonts from your computer and then trace the letters with a pen.

Lost Art

I recently read a horrible story in the paper. Apparently a Romanian woman's son stole a number of works of art from a museum in Rotterdam, paintings and drawings by Matisse, Monet, Gauguin, Picasso, Lucian Freud, and more. Convinced that if the paintings no longer existed, her son could not be prosecuted, the woman burned them all in the stove. Experts analyzed the ashes and concluded that her grim tale is almost certainly true. These masterpieces are lost to the world forever.

As I sat in the kitchen reading this sad story, my mind wandered off on a tangent. How many works of art have I destroyed? Not literally in my kitchen stove, but in the furnace of my mind. How many paintings have I not done? How many drawings have I aborted? How many pots have I not thrown? How many films have I not made? I thought of all the times I thought I should do some drawing and instead watched **Real Housewives**. I thought about that etching class I was thinking of taking last year and didn't. Poof, all those would-be etchings went up in smoke. Or that three-week trip I took to Japan when I didn't do a single sketch in my book.

This isn't my inner critic talking, brutalizing me for my indolence. It's just a fact. Every time you find a reason not to create, the art you might have made doesn't exist. It may not have all been great art, worthy of Rotterdam's museum, but it would have been another step on the path to better art, more fluid, more expressive, more fun.

What have you *not* made? And how can we fight the fire?

Embellish

o for Baroque. Draw a frame around your page. Make curlicues in your letters. Use a pen with gold or silver ink.

Draw some lines with a glue stick. Drop a sheet of gold leaf on to it (you can find it at the art supply store and it's pretty cheap, actually; all that glitters isn't real gold). Rub it down and brush away the excess. Keep the edges rough if you like.

Dip a toothbrush into ink or watercolor. Drag your finger across the brush to make a splattery spray of small dots.

129

EMBELLISH SOME MO'

Add a layer of collage to your drawing. It could be a photo or some words, a map or some texture. You can use it as background or turn it into something else with a few lines.

Add ephemera that adds meaning. Draw your dinner then paste down the bill. Visit a museum and glue in your ticket. Clip an article out of the paper and illustrate why it matters.

Tracing — it's allowed

Open a magazine or book to a big juicy picture. Cover it with a sheet of tracing paper and start to outline the shapes you see. Does your line feel more confident because you don't have to hesitate and make decisions? Could you capture that bold feeling in drawings of your own?

Now try some variations. Try reproducing the shading in the photo with hatch lines. Or use pencil to copy the tones. Try to make a half dozen different tracings, each with a different technique or style or emphasis. Feel as you draw. Turn tracing into something original, a work of art.

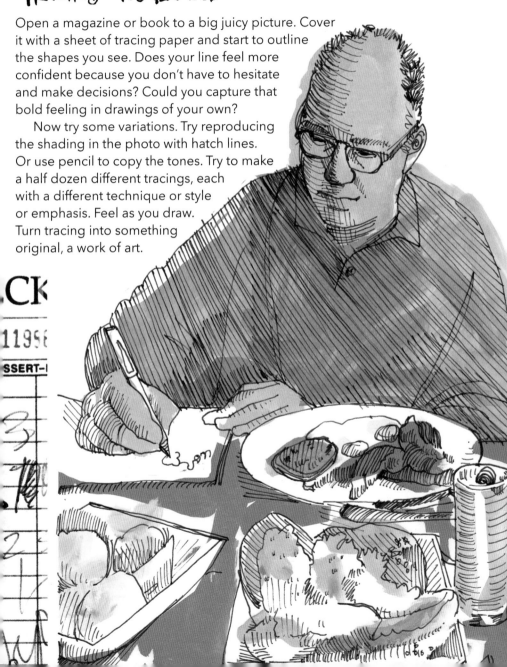

stepping up
and out.

Okay—you've drawn every stick of furniture in your house, every crumpled sheet and half-eaten sandwich.

Now for something completely new. The fancy term for it is *en plein air*. The groovy term is "urban sketching." We'll just call it, I dunno, "going outside to draw."

Ready?

Pack your bags

At first, just bring along your book and a pen. But with time you may want to expand your traveling art kit. Here are some very useful tools.

A watercolor field box: It folds up nice and small. Get the best one you can afford. It will last forever.

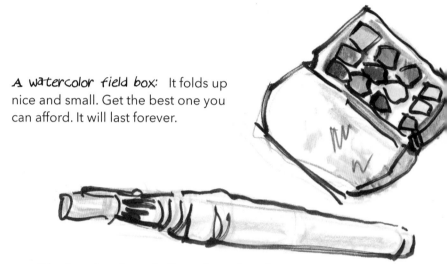

A waterbrush: It has a hollow plastic handle so you need never carry around buckets of water. Give it a squeeze and it's wet and ready to go. Clean it with another squeeze and a wipe on your jeans.

Watercolor pencils: Compact. Flexible. Don't bring along every color known to man. Just the basics. Oh, and a small sharpener.

Camera phone: Snap a few pics for reference. You may want to add some finishing touches later on.

A folding stool: Lightweight, folds up small, available at sporting-good stores. About $20. Now you won't need to look for a convenient bench or sit on the cold, hard ground. You'll be sitting pretty in Sketching City.

A candy bar: You've earned it.

Courage: You may feel comfortable plopping down on the sidewalk and just drawing the view. Or the potential of drawing attention instead might freak you out.

So go incognito. You could just sit against a building so no one can see what you are doing. Or sit in your car. Or get a corner table in a diner and draw what you see out the window.

Eventually you'll realize that no one cares what you are doing. If they pay attention at all it'll be to give you praise and to say they wish they could do these same. Trust me, I have drawn, well and badly, all over the world, and no one has ever laughed at me. Well, at least not because I was drawing.

My Perspective on Perspective

About six hundred years ago, Filippo Brunelleschi figured out the laws that describe perspective, and ever since, art students have walked around with rulers and protractors. Let's not, shall we? All you really need to know about perspective is that when things are far away, they look smaller. The front of a building that faces you has straight lines, up

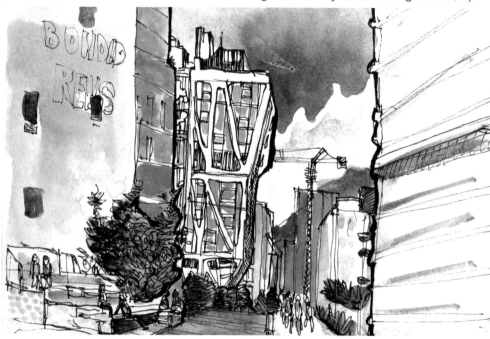

and down, side to side. But the sides of the building slope away from you and make a triangle with the end bitten off. But you don't need tools or laws to figure this out. Just the two eyes mounted on the front of your head. Pay attention and draw what you see.

Spend a minute looking at the building. Use your pen or thumb to measure where the midpoint seems to be. Be objective and not swayed by preconceptions. The building may be ten stories tall from

where you stand, but the third floor may actually appear to be in the middle. Perhaps the width of the side looks about half the width of the front. If it slopes away from you on the side, pay attention to where the back corner sits. Maybe it lines up with the fourth floor at the front.

THE CORNER OF 47TH and LEXINGTON AVENUE

Now draw the entire outside of the building in a single line. Up the right side, across the roofline, down the side, the back, the ground, and back to the front. Go slow but be bold.

Now fill in as much detail as you want. Put in the windows and doors. Pay attention to their relationships. Space them properly so you don't accidentally put in a few and then run out of space. Don't bore yourself by drawing thousands of shingles or hundreds of windows. Indicate enough to make the point. Draw in every brick or just outline a few. Put in the trees later or not at all. It's up to you.

The main thing to keep in mind is that you are an artist, not an architect. Capture the spirit of the building, its age, its personality. Don't worry about perfection. Feel the building, the landscape, the weather. Own the real estate.

No No-Man's-Lands!

When you are concentrating on drawing a city landscape, you may be tempted to skip the people who wander through it, as if a neutron bomb had just surgically eliminated all human life. After all, buildings are far more cooperative than pesky humans; they sit quietly and never budge. But even if you draw people in a loose, shorthand way, you'll still capture the movement and hustle-bustle that brings a city alive.

Try stick figures, or gestural, blobby people made up of a head, an oval body and loops for arms and legs. They'll add scale and motion to an otherwise static drawing.

$4.0

139

IN THE RETURNS LINE at COSTCO.

DRaw the UNSuspecTiNG

Whenever you encounter a big group of people, take the opportunity to draw them.

At a movie theater, waiting for the lights to dim, draw the backs of the heads in front of you. As the parade passes by, draw the spectators. As the opening act warms up the crowd, sketch the concertgoers on the back of your program. At the DMV, on the subway, in a doctor's office, take advantage of the situation and draw the people waiting. They are bored, and you are making art.

Concentrate on the feelings you see, and don't insist on capturing an accurate likeness. Work quickly–try to capture the postures, expressions, and gestures you see with just a few lines. Be prepared for your subject to suddenly move to a new position or out of eyeshot. Just move on to the next person. Cover your page with quick studies.

Bubale de
Jackson -
Africa

142

This place is A Zoo!

Wild animals are great models, too. If they're dozing in their enclosures, it's easier to draw them, but more interesting images come when they move. Spend some time watching them before you uncap your pen. Watch the patterns of their movements. You'll find that they tend to repeat their movements, which makes it easier to capture changes. Work on several small drawings at once and on the same page, quick sketches of each position in the animal's cycle of movement. Go back and forth between the various views, adding details and observations. The adrenaline rush of not knowing if they will suddenly break their pose will make you super-alert and observant.

Baby, it's cold outside

When it's too cold and dismal to draw outside, go to your bookshelf or magazine rack for inspiration. Here are some ideas for making other people's images into your own own art.

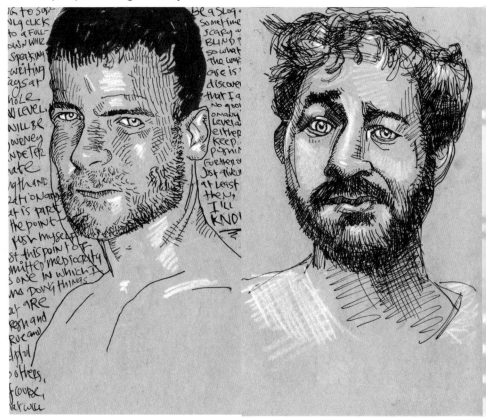

Drawing from magazines, books, and photo albums.

If you are at a loss for subject matter, it's okay to draw from magazines and books. But bear in mind that interesting art doesn't come from trying to slavishly turn a photo into a drawing. Try to add as much as you can of your own to the image. If it's black and white, make it color.

If it's color, add a twist, a new background, some form of distortion, some props. Consider how the image makes you feel and express that feeling in your work. You are the most important piece in the process, not the photo of Brad Pitt. Your *feelings* about Brad are actually the subject.

Drawing ON magazines.

Here's a good way to gain confidence in your line. Crack open a magazine or a catalog and look for a strong, appealing image. With a big, indelible marker like a Sharpie, trace around the edges and outline the major shapes. Highlight the defining features of the person, the shape of their nose, of their eyes, their hair. Use a pencil eraser to remove the printed ink to add highlights. Don't add a mustache and glasses. It's doodling, but it's also a lesson.

AHA! Snap Judgment

Don't get me wrong—drawing from a photo is better than not drawing at all. But without the right approach, it can be a second-rate experience. You can usually tell when a drawing or painting was copied from a photo. It has a flatness, a lifelessness, an unreality to it. It may be more accurate, like a tracing, but it lacks the artist's touch. It lacks soul.

Drawing is about creating a relationship with the thing you are drawing. But if you are far from the scene you are drawing, you're capturing only the idea of that thing. If you're drawing a barn in the middle of Oregon, or a model in a community college classroom, lots of things go into how you're feeling at that very moment, things that impact every line you draw. Sight might seem like the most essential sense when you are observing and rendering something, but your other senses are still affecting you and how you process the experience.

Another issue is that you are digesting something an artist has already digested. When a photographer takes a photo, he's already made a lot of decisions for you, the viewer. He puts a frame around a certain part of the world and chooses what's important—the composition, the colors, the focus. That's the same thing you do when you set out to make a drawing.

So, isn't it easier if the photographer has already done the work for you? Well, yes and no. Instead of putting yourself into what you are seeing and drawing, you are just commenting on his preexisting view, chewing his cud.

And finally there's the IMAX effect. A camera has only a flattened, two-dimensional view of the world, whereas humans see with both eyes. When we draw, we, binocular bipeds, take that information from both eyes and combine it to make our lines. The drawing is a merger of what both of our eyes see and what our brains understand instinctively.

Not to be a snob, but it's sort of like having a frozen pizza. Sure, it's a "pizza" but it ain't really the real thing.

So ask yourself, "What am I trying to accomplish by turning this photo into a drawing? What else am I bringing to it? Can I slice some fresh mushrooms onto that pizza? Maybe spice it up with some oregano and crushed garlic? Open a bottle of wine?" Now, you have a feast.

Drawing from your own photos

When you draw from a photo you took yourself, you avoid some of these problems. You chose the moment, the angle, and the framing, and you had the experience of the moment, the smells, the sounds, and the feelings of being there. Try taking a bunch of pictures, from different angles, including details. Use these pictures as notes and reminders. Your drawing will be an original image, your own conglomeration of all that you saw.

147

tell your story

Your old photo albums and yearbooks are also great places to look for inspiration. Sitting with an image from long ago and really studying it as you draw can crack open the vault and bring out a flood of feelings and memories. Draw your childhood toys, your first pet, what you can remember of your first bedroom.

Draw your classmates from high school. Your teachers. Your own pimply face.

Explore pictures of your parents when they were young, your grandparents, the places they came from. Create a few pages of visual memoir—or fill a whole journal.

Kid Academy

Part of an artist's education is studying and copying works by the masters— Rembrandt, Titian, van Gogh. Copying, as exactly as you can, every stroke, every decision, so you really understand how the work was made. You should try that sometime, but that's not what we're gonna do today. Not exactly.

Get a drawing by a little kid. If you don't have any children of your own, borrow a drawing by a neighbor's kid, or go through your archives and find one you did a hundred years ago. If all else fails, Google "kids' drawings" and print one out.

Now, sit down with a crayon or pencil, and copy the kid's masterpiece. Draw each line exactly. Reproduce the pressure of the crayon, the speed of the scribble. Let yourself drift into a kid's mind set. See where he made decisions. Feel her energy. Find the same spirit inside yourself. Remember what it feels like so you can summon that up again when you make drawings of your own. The passion, the intensity, the freedom, the fun.

\mathcal{S}toryboard

Tell a story in a small series of quick drawings and words.

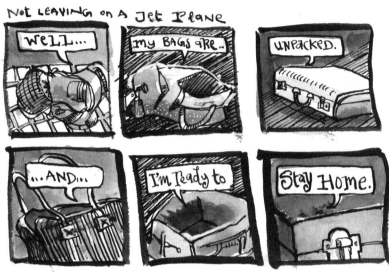

Turn a joke into a comic strip.

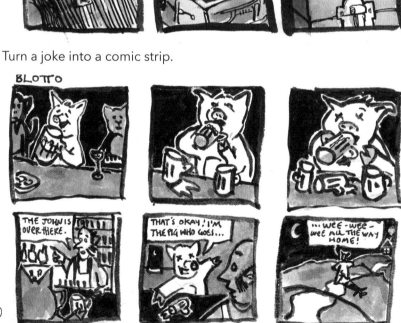

Record a conversation in drawings.

Draw instructions or a recipe.

Travel Journaling

When you visit a new place, open your eyes. And your sketchbook. Look at the famous sites, sure, but also look at what sort of cars people drive, how they dress, at their garbage cans, their newspapers, their buses. Get it all down in drawings, paintings, and words.

DEJEUNER a Baguette avec Jambon et fromage.

PONT.NEUF

ITALIAN.GIRLS.PICNICKING.

.AMUSEMENT.PARK.BY.TUILERIES.

I'm glad to have some thing of hers with me so far from home.

...his and ...iland.

Old, Stone non-Gnomes.

China has had a big influence on Bangkok over the centuries. Allegedly, many of the random statues that litter the grounds of Wat Pho were ballast brought back on emptied tea-carrying ships from Thailand on the return journey.

Seeing a new country means a new perspective, on the place, on the world, and on yourself. You spent thousands on this trip, so get your money's worth. Don't leave it just to snapshots and postcards. Record it indelibly in your memory—by making art.

And the same goes double for business trips. Get all you can out of the moments between meetings and client dinners. Draw everything that's fresh and new to you.

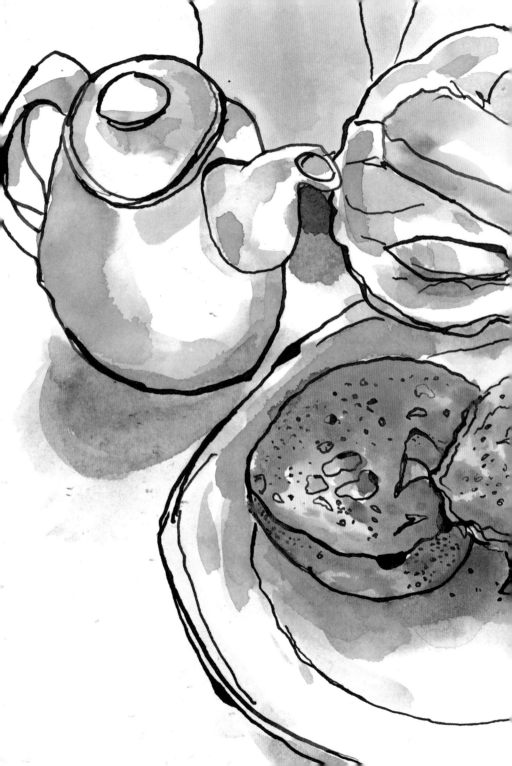

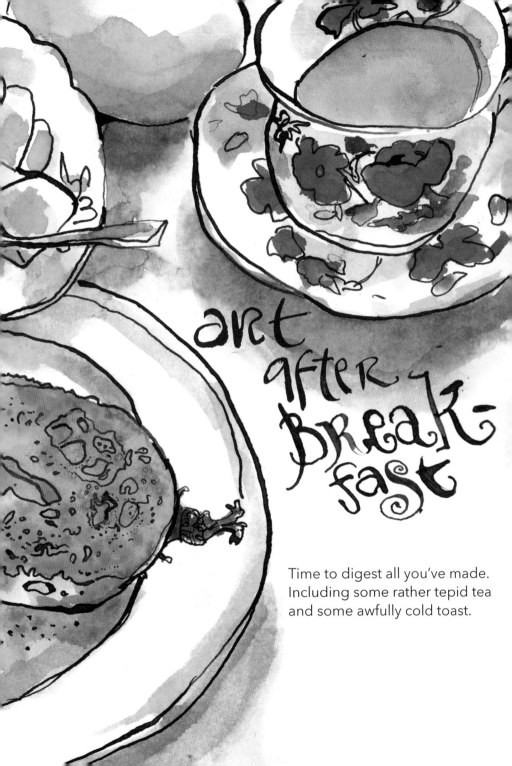

art after Breakfast

Time to digest all you've made.
Including some rather tepid tea
and some awfully cold toast.

AHA! WHAT is the ART of Life?

Life is not an oil painting, sealed behind varnish and clamped in a golden frame, hanging in a white-walled gallery in Chelsea, waiting to be bought by a hedge fund manager's third wife.

Life is not an edition of etchings, a long series of identical impressions.

Life is not a mural, intended as a public display or the backdrop to an expensively furnished room. Life is not wallpaper.

Life is not a bronze sculpture—cold, monumental—an abstracted, idealized image of a hero long forgotten.

Life is a shelf.

A long shelf partly filled with illustrated journals. Some of the books are handmade, some store-bought, some in ornate covers, some stained and dog-eared. Some of the journals are completely filled. Others are abandoned halfway, maybe to be taken up at a later date. Some of the books are filled with paper that felt just right under your pen, smooth and creamy, bold and bright. Others were experiments that failed or overreaches made of materials you weren't ready to master quite yet.

Sections of the shelf may be filled with identical volumes, a type of book that you found comfortable at the time and stuck with it, disinterested in experimentation and change, so you kept filling one after another.

On the shelf, they may look the same, identical spines all in a row. But inside, each page is different, drawn by the same hand and pen, yet recording unique observations, days that fill up identically sized boxes on the calendar but were all filled with different challenges, discoveries, lessons, and dreams.

Each page of each journal is always different. Some are perfectly drawn and brilliantly written, insightful and illuminating.

Others are a failure, with poor perspective and distracted lines. Some of the pages are dappled with raindrops or a splash of champagne, others are drawn in haste, still others crosshatched with great intensity and care. Some contain shopping lists, phone numbers of new friends, boarding passes to far-away places. Some are bright and colorful, witty and bold. Others are intimate and personal, never to be shared. Some pages describe loss and death, others drawings of a gift you took to a baby shower.

None of these pages is an end in itself. No matter how good it seems at the time, eventually, you turn each one over. Even the ones at the end of a volume are merely leading to the first fresh page of the next. You fill the page, maybe you like what you drew or maybe it was a disappointment, but there's always another to follow and another beyond that.

You try your best with each blank page, try to make something fresh and beautiful. Some of the time you feel excited and proud of what you've made, at other times you are disappointed and desperate. Often, a page you thought was just a turd looks a whole lot better when you come back to it years later. The drawing you thought was clumsy and flawed reveals some new insight and truth about who you were at the moment, fresh energy, naivete, hope, darkness before the dawn.

Each drawing, whether you know it at the time or not, contains truth. You just have to trust it and keep on drawing and writing and living your life.

Life is a process, and every one has the same end result: that last volume, partly filled, cut off when we thought there was still art left to make.

No need to rush to get there. Make the most of the page that lies open before you today.

Sharing your work

Art is a dialogue. So far, you have been talking mainly to yourself, but now it's time to share with others. You may hesitate, worried that people won't like what you are making, concerned that their opinions could stop your creative growth.

Don't be.

I promise you that most people will be blown away by what you have made already, and wish they could do the same. You should encourage them to join you. Lend them this book—or better yet, buy everyone you know a copy(!). Draw with them. Share experiences and discoveries.

If you are still concerned, then consider sharing your work with people you don't know, on the Internet. Join one of the groups we have started for creative beginners on Facebook or Yahoo! (Just search for "Everyday Matters" or visit DannyGregory.com to track it down.) You can upload your favorite journal pages and they will love them! It's a great way to make life-long friends who share your passion.

If you are still hesitant, share your feelings with me. Write a quick note to me at danny@dannygregory.com and I promise I'll be supportive and never mean.

The Final Aha! Don't Stop here

It's time to flip back through the pages of your sketchbook and see how far you've traveled.

You have achieved some amazing things in the spare moments between appointments and chores, haven't you? You've learned how to draw, how to paint, how to see the world. But most of all, I hope that you have learned to see yourself and your time differently. That you have learned how much you can create and how great it makes you feel.

Your time is your own. And now you know how to make the most of it.

Life is not just a relentless tumult of obligations. It's a wonderful gift, full of mystery and beauty. And by making art, you have made it yours. You have absorbed and explored it and it has changed you for the better.

See, I told you. You can do it. You are an artist, after all.

I just know you're going to continue with your new habit, documenting your life in your sketchbook, for many years to come. And I hope you will also branch out, will make more time for making things, will explore new media, new forms, new subjects, and new experiences.

Breakfast is over. And I hope you're still hungry.

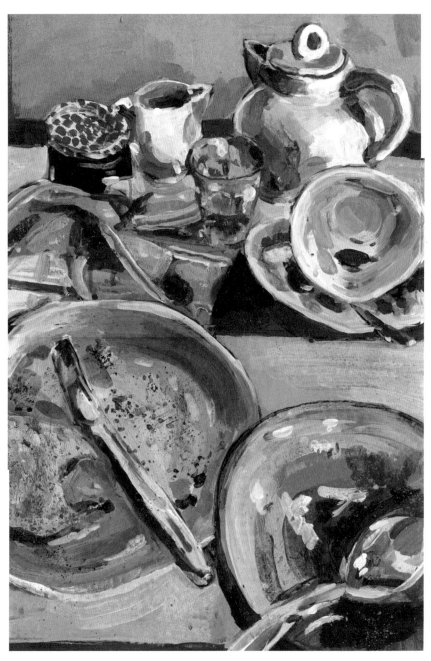

visit artB4breakfast.com